PHARAOHS

PHARAOHS

LAWRENCE M. BERMAN

BERNADETTE LETELLIER

Treasures of Egyptian Art from the Louvre

The Cleveland Museum of Art
in association with
Oxford University Press

Presentation in Cleveland
made possible by

A KeyCorp Bank

Covers: Detail of *Seated
Statue of Amenhotep IV
(Akhenaten)* [13]

Hieroglyphs: Kings of Upper
and Lower Egypt

Published on the occasion of the exhibition
*Pharaohs: Treasures of Egyptian Art from
the Louvre*, organized by the Cleveland
Museum of Art in collaboration with the
department of Egyptian antiquities, Musée
du Louvre, Paris. Exhibition made possible
by Society Bank/KeyCorp, with additional
support from the National Endowment
for the Arts, a federal agency, and the Ohio
Arts Council.

Copyright © 1996 by the Cleveland
Museum of Art. All rights reserved. No
part of this book may be reproduced or
transmitted in any form or by any means,
electronic or mechanical, including photo-
copying, recording, or any information
storage and retrieval system, without per-
mission from the publishers.

Editor: Barbara J. Bradley
Designer: Thomas H. Barnard III
Production Manager: Charles Szabla
Printing: Nissha Printing Co., Ltd., Kyoto

All translations from the French are by
Lawrence M. Berman. Figures in brackets
[] refer to catalogue numbers. Transla-
tions of ancient Egyptian texts are by the
authors unless otherwise noted. In the
Documentation section, frequently cited
exhibitions and publications are referred to
using the place-date or author-date system.
All such exhibitions and publications are
documented completely in the Exhibitions
and Publications listings.

Photo credits: All photographs of Louvre
objects are copyright Photographic
Services, Réunion des Musées Nationaux,
unless noted otherwise. All photographs
of Cleveland Museum of Art objects are
by the museum's photography department,
unless noted otherwise. The following
photographers are acknowledged, with
figures in parentheses () referring to page
numbers: Lawrence M. Berman (50),
courtesy Service Culturel du Musée du
Louvre (17), Bernard Terlay (85).

Map and line drawings by Barbara J.
Bahning Chin.

LIBRARY OF CONGRESS CATALOGING-
IN-PUBLICATION DATA
Berman, Lawrence Michael, 1952–
 Pharaohs : treasures of Egyptian art
 from the Louvre / Lawrence M. Berman,
 Bernadette Letellier.
 p. cm.
 Includes bibliographical references.
 ISBN 0–19–521235–5 (Oxford pbk.)
 ISBN 0–940717–31–X (CMA cloth)
 ISBN 0–940717–32–8 (CMA pbk.)
 1. Portrait sculpture, Egyptian—
 Exhibitions. 2. Portrait sculpture,
 Ancient—Egypt—Exhibitions. 3. Egypt
 —Kings and rulers—Portraits—
 Exhibitions. 4. Portrait sculpture—
 France—Paris—Exhibitions. 5. Musée
 du Louvre. Département des antiquités
 égyptiennes—Exhibitions. I. Letellier,
 Bernadette. II. Cleveland Museum of
 Art. III. Title.
 NB1296.2.B47 1996
 732'.8'07444361—dc20
 95-45358
 CIP

Contents

Pharaohs: Treasures of Egyptian Art from the Louvre is the latest exhibition collaboration between the museums of France and the Cleveland Museum of Art. This partnership dates back to *The European Vision of America* (1976–77) and *Chardin* (1979) and includes the Cleveland museum's great seventy-fifth anniversary exhibitions, *Picasso and Things: The Still Lifes of Picasso* (1992) and *Egypt's Dazzling Sun: Amenhotep III and His World* (1992–93). Now this long-standing partnership continues with the loan of thirty outstanding objects from the Louvre's Egyptian collection, arguably the world's finest outside of Egypt. And herein lies a tale.

When the Cleveland Museum of Art began to consider appropriate ways to celebrate the city's 1996 bicentennial, it soon became clear that a program of exhibitions, of particular and varied character, should be developed. One component was to be an exhibition of international stature. The first choice to implement this aspect of the bicentennial series was an exhibition of Egyptian art drawn from the collection of the world's first museum to be organized according to modern, democratic principles—the Louvre in Paris. The timing of this exhibition happened to coincide with the long-awaited renovation of the Louvre's Egyptian galleries, which will reopen in early 1997. A loan request was thus more feasible than it otherwise might have been. Assistant Curator of Ancient Art Lawrence Berman assumed the task of conceiving the exhibition and decided that by presenting masterpiece images of pharaohs we could provide the public with an interesting, pointed view of Egyptian kingship and culture. After all, when you deal with pharaonic objects you deal with the pinnacle of patronage and production. Thus *Pharaohs* was transformed from a curatorial idea into an exhibition and programmatic reality.

The works in the exhibition are all masterpieces of Egyptian art. Spanning the entire history of Egyptian civilization, they range in date from 3000 BC to AD 68. Not just a show of masterworks, the exhibition is designed to give a focused view of the changes and continuity in Egyptian art through royal imagery. It also provides fascinating insights into the changing concept of the pharaoh over time. Looking at and understanding these works brings many artistic and social/political issues to the fore and makes the exhibition a significant exploration for the eye and the mind. The presentation is designed to capture both the powerful spirit of the objects and the historical imagination of the audience.

On the next page, Larry Berman acknowledges the many people involved in the splendid collaboration that made *Pharaohs* possible. Of course, our greatest debt is owed him, for conceiving the idea for the exhibition and for carrying through on the intellectual and practical requirements needed to complete the undertaking. We are also grateful to Christiane Ziegler, head of the department of Egyptian antiquities, and to Bernadette Letellier, who worked with Larry Berman on all aspects of the project and served as co-author of this catalogue.

Presentation of *Pharaohs* has been made possible by a generous grant from Society Bank/KeyCorp, whose corporate support benefits Cleveland's civic life in so many ways. Special thanks to KeyCorp Chairman Robert Gillespie for championing the show and to Bruce Akers, vice president for public affairs at Society Bank. The National Endowment for the Arts supported the initial research for the exhibition and catalogue, and additional funding has been provided by the Ohio Arts Council.

Pharaohs—the exhibition, the catalogue, the extensive public programs—puts superb art and scholarship in the service of a broad audience. As such it appropriately reflects the aspirations to excellence of the Cleveland Museum of Art and the Louvre in all aspects of their public-spirited missions.

Pierre Rosenberg
Président-Directeur
Musée du Louvre

Robert P. Bergman
Director
The Cleveland Museum of Art

This exhibition has been, above all, a collaboration among friends. The blessing of Director Pierre Rosenberg was essential to the project's success. Christiane Ziegler, head of the department of Egyptian antiquities, graciously agreed to the exhibition at a time when her staff was already engaged in the monumental task of seeing to the movement, conservation, and reinstallation of 55,000 objects in their glorious new setting. Bernadette Letellier was the perfect colleague. Tireless, energetic, and endlessly patient, she brought to the project her commitment and scholarship and a most welcome sense of humor. It has been a privilege to work with her. Elisabeth Delange worked on the initial, conceptual stages of the exhibition. Marie-France Aubert, Catherine Bridonneau, and Sylvie Guichard also provided valuable assistance.

In Cleveland, Director Robert P. Bergman presided over every aspect of the project, and I am grateful for his guidance and support. Deputy Director William S. Talbot aided with administrative matters. Kate M. Sellers, director of development and external affairs, and Michael R. Weil, Jr., corporate relations manager, worked energetically in support of the exhibition. Associate Registrar Carolyn T. Thum planned shipping and insurance methodically and carefully.

The exhibition was designed by Jeffrey Strean. The catalogue was produced with the enthusiastic support of Laurence Channing, head of publications. It was designed by Thomas H. Barnard III and edited by Barbara J. Bradley. Their elegant touch and eye for detail are apparent on every page of this book. Ann B. Abid, head librarian, and her staff were extremely helpful. Marjorie Williams and Joellen DeOreo planned educational programs. It has been a pleasure to work with them all. I am also grateful to others who were involved with the project in its early stages but have since retired or moved on to positions elsewhere: Delbert R. Gutridge, Adele Z. Silver, Ilana Hoffer Skoff, and Lawrence J. Wheeler.

Nothing could not have been accomplished without the support of my colleagues in the department of ancient art. Arielle P. Kozloff has been a source of strength and inspiration throughout. Sharon Herene facilitated my every task. Elisha Dumser assisted in various ways. Help also came from other curatorial departments. Alan Chong, associate curator of paintings, took time to read over the draft of my essay. Diane De Grazia, chief curator, and Katherine Solender, exhibition coordinator, embraced the project with enthusiasm.

My heartfelt thanks to all these and still others who have helped bring *Pharaohs* to Cleveland. LMB

Lawrence M. Berman

Few images in the history of art can compare in majesty with that of the pharaoh on his throne. The very word "pharaoh" conjures up images of venerable antiquity, pyramids and obelisks. It derives from the Egyptian *per-aa* (great house) and originally meant the royal palace or administration rather than the king himself. Not until the reign of Tuthmosis III (fifteenth century BC) is it applied to the royal person, much as we use the "White House" to denote the president of the United States. This usage is reflected in the Old Testament stories of Joseph and Moses, from which the term comes. Followed by the name of a specific king, Pharaoh So-and-so, it does not occur until the reign of Shoshenq I (tenth century BC). The Egyptians had other designations for their rulers, of which the oldest was "Horus"—the falcon god of sun and sky, of whom the king was the earthly embodiment [2, 10]. The term that probably comes closest to our word for king is *nesu* (king of Upper Egypt), more fully *nesu-bity* (king of Upper and Lower Egypt). But of all the terms the Egyptians used to refer to their kings (as opposed to rulers of other lands, who were simply "chiefs" or "rulers"), only "pharaoh" survives to the present day.

Pharaohs presents thirty images of Egyptian rulers from the renowned collections of the Musée du Louvre, Paris. Few collections in the world can boast such an impressive array of royal images. The Louvre's department of Egyptian antiquities was founded in 1826, with Jean-François Champollion, the "Father of Egyptology" and decipherer of hieroglyphs, as its first curator. Its extraordinary development virtually parallels the history of collecting Egyptian art. The fabulous collections assembled by the British and French consuls in Egypt Henry Salt and Bernardino Drovetti, purchased in 1826 and 1827, formed the nucleus of a department steadily enriched over the years through excavations in Egypt and an acquisitions policy devoted to the pursuit of rare and beautiful objects. The result is a collection remarkable not only for its size (roughly 55,000 objects) and historical importance but also, and especially, for its taste and aesthetic quality. All these phases of collecting are represented by the works of art in this exhibition.

The choice of subject—royal representations of all periods of Egyptian art, from Predynastic to Roman—is appropriate, for the king was the greatest patron of the arts in ancient Egypt, and he commanded the best artists. The expenditure involved in building projects, which included statue manufacture (an integral part of temple decoration) was prodigious. Expeditions were sent to the quarries to extract quantities of choice stone, in which Egypt abounds:

hard stones like quartzite from Gebel Ahmar, near Cairo; red granite and granodiorite from Aswan; graywacke from the eastern desert; and soft stones such as limestone and travertine (Egyptian alabaster), found along the Nile. Each type was prized for its specific color and texture. Curiously, the Egyptians did not care much for marble, using it only sparingly; the marble quarries in the eastern desert were exploited mainly in the Greco-Roman Period.

Royal monuments—architecture, sculpture, and relief—were a demonstration of the king's piety and also a tangible expression of his power and efficacy as king. Each ruler strove to surpass his predecessors. Thus Amenhotep III [12] boasted of "making very many great monuments, the like of which never existed before since the primeval time of the Two Lands." The long-lived Ramesses II [18] so overshadowed his successors with his monuments that nine kings in a row chose to bear his name, hoping to emulate him. Only one, Ramesses III, even came close. Nonetheless, the ambitious but short-lived Ramesses IV [20] claimed to have done more for the gods in his first four years of rule than Ramesses II had in sixty-seven, which is scarcely to be believed.

Egyptian art is often regarded as static, and indeed it maintained a remarkable continuity for more than 3,000 years. No civilization was ever more aware of its past, ever holding it up as a model: to return to "the primeval time" was held up as an ideal. An exhibition such as this one, focusing on a single theme as it developed over time, highlights the changes that did occur. Compare Djedefra [3] with Tuthmosis IV [11], 1100 years later, or Amenhotep III [12] with Apries [23], 800 years later. Not only the faces, but even the forms of the headdresses have changed. While the portraits of Sesostris III [5] and Akhenaten [13] are clearly innovative, they are part of a living tradition, purely Egyptian. Even the *Head of an Achaemenian Ruler* [25], looking nothing like a pharaoh, is a part of that tradition (the Egyptians relished depicting foreign features and costumes). Yet the portrait of Nero [30] seems to belong to another world, for the Roman emperor wears his pharaonic regalia like a costume.

The works of art depict the king in various roles. As a victorious ruler, he appears on the *Bull Palette* [1] as a bull trampling an enemy. Scenes on temple walls [22] show the king offering to the gods. Roles often defined or prescribed the ruler's appearance. Thus, on the *Stele Dedicated to Queen Cleopatra VII Philopator* [29], antiquity's best-known femme fatale offers to Isis and Horus in the time-honored guise of a bare-chested male pharaoh. The king was the sole intermediary be-

Trial Piece with Four Studies of Heads. Limestone, h. 34.4 cm (13½ in.). Probably Thebes. New Kingdom, Dynasty 18, reign of Amenhotep III, 1391–1353 BC. The Cleveland Museum of Art, gift of the John Huntington Art and Polytechnic Trust 20.1975

tween the world of humanity and the world of the gods; through temple ritual, he upheld the order of the universe. This most fundamental role is summed up in an Egyptian text, the *King As Priest of the Sun God*, as follows:

> Ra has placed the king
> on the earth of the living
> for ever and eternity,
> judging humanity, satisfying the gods,
> realizing Right, annihilating Wrong.
> He gives offerings to the gods
> and funerary offerings to the dead.

Bernadette Letellier

Even today, many in France believe the Louvre houses the treasures brought back from Egypt by Bonaparte. They forget easily that the capitulation to the English in 1801 cost him his plunder, but they regain their memories when it comes to deploring the loss of the famous Rosetta Stone, which was part of the same booty. Napoleon became emperor in 1804 and did, in fact, bring a few Egyptian works into France with the Borghese collection, which had been purchased in Italy where such *cabinets d'antiques* (private collections of antiquities) had been assembled during the second half of the eighteenth century. Essentially, the department of Egyptian antiquities was a creation willed by Jean-François Champollion (1790–1832). Before him, until Charles X came to the throne in 1824, the few purely Egyptian works in the Louvre had been part of the royal collections. Those pieces had been integrated into the department of antique sculpture, which was founded in 1793. Accordingly, the acquisitions register of the reign of Louis XVIII (1814–24) mentions only sixteen Egyptian objects. This ensemble hardly represented the ancient civilization as we know it today. It included some genuine Egyptian works, such as the statues of the cat/lioness-goddess Sekhmet brought back in 1817 by the Comte de Forbin,[1] and the beautiful *Statue of Nakhthorheb* (purchased in 1816 from Sallier[2]) as well as pieces restored according to the classical taste—pastiches—such as the colossal Roman Isis.

Moreover, little was known about Egyptian art at the time. Cultured people were irresistibly attracted by Late Period works or Egyptianizing products (Roman or eighteenth century) and were unable to distinguish authentic works. The Napoleonic Expedition had revealed the culture to the Europeans, but, still impregnated with the old taste, members of that campaign were dazzled at first by the great Greco-Roman temples. Champollion was without doubt the first to become aware of Egyptian art when he visited the country in 1828–29. In his correspondence he criticized the Napoleonic Expedition for praising the Ptolemaic and Roman temples, whose bas-reliefs appeared ugly to him, at the expense of those of Thebes, which they did not properly appreciate. Champollion's enthusiasm for the art of the New Kingdom, which he discovered, often led him to make exaggerated claims: "The bas-reliefs of Dendara are detestable, which could not be otherwise, as they are from a period of decline" (letter to his brother Champollion-Figeac, Thebes, 24 November 1828).[3]

Jean-François Champollion. Oil on canvas, 73.5 x 60 cm (28½ x 23½ in.), 1831. Léon Cogniet, French, 1794–1880. Paris, Musée du Louvre, inv. 3294

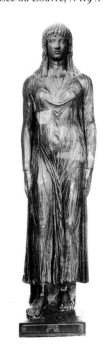

The Goddess Isis. Stone, h. 256 cm (8 ft. 3 in.). From Hadrian's Villa at Tivoli, AD 117–38. Paris, Musée du Louvre, N 119 A

The Era of the Founders

Champollion not only imposed his interpretation of the system of hieroglyphs[4] and organized the world's first Egyptological museum (in Turin, Italy), he also fought to modify the taste of his contemporaries to make them share his love of ancient Egypt. That ambition led to the founding of a museum in Paris. On 15 May 1826, an ordinance of Charles X created an Egyptian division at the Musée Royal du Louvre, and Champollion was appointed curator.

In the early 1800s, there was no such thing as national cultural patrimony. In addition, everyone was convinced that the antiquities of Egypt were doomed to rapid extinction because the Egyptians themselves were quickly dismantling entire temples to reuse the materials. The best way to save the monuments seemed to be to remove them to Europe. Not until the creation of the Egyptian Antiquities Service by Auguste Mariette (1821–1881) toward the end of the century did another concept of safeguarding the monuments assert itself, and that, too, had ulterior motives as it was stimulated by a bitter rivalry among the French, English, and Germans.

During a good part of the nineteenth century, the major suppliers of antiquities were the European consuls stationed in Egypt. The first collection of Bernardino Drovetti (1776–1852), an Italian diplomat appointed consul-general of France in Alexandria by Napoleon, was acquired by the king of Piedmont and became the nucleus of the collection of the Egyptian Museum in Turin. That lot having escaped France, the 2500 Egyptian objects acquired in 1824 from the sale of the collection of Edme Auguste Durand constituted the point of departure of the "Musée Charles X."

In just a few years, thanks to a massive acquisitions policy, Champollion succeeded in assembling some 9000 objects. In 1826 he secured the 4000 pieces—including the *Statuette of Amenemhat III* [6], the *Seated Statue of Sebekhotep IV* [8], and the *Seated Statue of Amenhotep IV (Akhenaten)* [13]—from the collection of English consul Henry Salt (1790–1827), whose agent was Belzoni.[5] Then, in 1827, the second Drovetti collection—more than 500 pieces including the *Head of Amenhotep III* [12] and the *Ostracon with Portrait of Ramesses VI* [21]—came to the Louvre. Champollion's travels in Egypt in 1828–29 enabled him to bring back another 102 pieces.

Having fulfilled his dream of importing to France testimonials of Egyptian civilization, Champollion wanted to make them known. He planned to give the collection an appropriate framework in the part of the museum that had been allotted to him—on the second floor of the south wing of the Cour Carrée. The architect Pierre François

Léonard Fontaine took responsibility for the project, calling on renowned artists Antoine-Jean Gros, Horace Vernet, Alexandre-Denis Abel de Pujol, and François-Jean Picot to execute the painted decor, which was inspired by Egyptian or biblical themes. The heavy mahogany vitrines, which seem so impractical today, were made for this occasion. The presentation of the objects in the four rooms was thematic: room of the gods, civil room, funerary rooms.

Egypt Saved by Joseph. Ceiling of Egyptian Antiquities Gallery C, commissioned 1826. Alexandre-Denis Abel de Pujol, French, 1785–1861. Paris, Musée du Louvre, inv. 2196

A letter in Champollion's hand, dated 21 June 1827, informs us that he was already fighting to expand his museum and obtain rooms on the first floor. He died without attaining his goal, and those rooms, transformed into storerooms, were only given to the department one hundred years later.

The sudden death of Champollion in 1832 took everyone by surprise. He died without grooming someone to take his place. His successor, Jean Joseph Dubois (1780–1846), had no particular competence in Egyptology, and the department was reassigned to "antiques," under the authority of the Comte de Clarac.[6] Dubois nevertheless went ahead in 1837 and acquired the archaic statues of Sepa and Nesa, pieces vital to the history of the sculpture of the Old Kingdom, from the collection of Consul Mimaut.[7]

With the appointment of Emmanuel de Rougé (1811–1872) in 1849, the Egyptian department awoke from its lethargy and regained its independence. Another important event occurred at that time: Auguste Mariette, who had been sent on assignment to Egypt in 1850 to do research on manuscripts, decided instead to conduct excavations in the necropolis of the ancient capital, Memphis. There, at today's Saqqara, he discovered the catacombs of the Apis bulls, the Serapeum. Between 1852 and 1856, he sent some 6000 objects to the Louvre, including an impressive collection of steles as well as the most famous statue in the Egyptian department, the *Seated Scribe* dating from the Old Kingdom. The *Relief of Tjutju Adoring King Menkauhor and Divinities* [17], the *Epitaph for an Apis Bull* [24], and the *Relief of Nectanebo II (Nakhthorheb) Adoring Apis* [27] in this exhibition were also sent by Mariette.

In 1825 Mohammed Ali (viceroy of Egypt, 1804–49) sent for the eminent French physician Antoine Barthélemi Clot, not to look after the enlightened prince's health but to help the country modernize. And, of course, like the consuls, Clot-Bey (distinguished foreigners were honored with this Turkish title) enjoyed collecting antiquities. Those objects would form the core collection of the museum of Marseille, but 2500 of them were acquired by the Louvre in 1853.

The second half of the nineteenth century was also the era of the great merchants and collectors who put their antiquities up for sale. The Louvre, profiting by the sale of the collection of Swedish consul Giovanni Anastasi (1857), acquired a fine group of Abydene steles. In quick succession followed the collections of the Chevalier de Palin (1859); Achille Fould (1860); Comte Eustach Tyszkiewicz (1862), who had assembled a beautiful series of bronzes; Russian vice-consul Salemann (1863); French consul Pacifique Henri Delaporte (1864); Alphonse Raifé (1867); and Rousset-Bey (1868). The *Head of a Saite Ruler, Probably Apries* [23] came from the Palin collection, the *King As Falcon* from Rousset-Bey [10].

The Reaction of the Aesthetes

Little controversy surrounded the installation of the objects in Champollion's museum. He had adopted a thematic organization that pleased the visitors of the time, educated people of leisure, and his successors had not questioned its basic principles.

The arrival of Eugène Revillout (1853–1913) started a small revolution. Between 1879 and 1896 Revillout—a man of great intelligence and an expert philologist, but an irascible and extremely disorganized person—put together an important collection of manuscripts (papyri, ostraca, mummy labels), showing a distinct preference for Late Period texts (Demotic, Greek, Coptic). Eager to display all his finds in Champollion's galleries, he papered the walls with steles and crammed the vitrines with manuscripts, irritating his colleagues and angering Jules Grévy, president of the republic, who found the museum very ugly when he visited in 1883. Revillout's tenure in the department was later covered up, unjustly. Yet the aesthetic reaction against his installation procedures remains in effect even today. Georges Bénédite (1857–1926), who was appointed in 1895, also left an indelible mark. He was the first to call into question Champollion's organization, defining it as "not taking any account of form and based solely on subject matter."[8] Bénédite's presentation was based on displaying the most beautiful pieces to their best advantage. He thus created the museum of masterpieces, with its corollaries, and many objects were relegated to storage "for study," and others, in great numbers and not always with good reason, were deposited in provincial museums.

With the era of the great collectors at an end, Bénédite did not hesitate to go to Egypt to explore the antiquities market. We owe him some very beautiful acquisitions.[9] In 1903 he obtained permission from the Egyptian government to export the mastaba chapel of

Akhethotep. The *Statue of the God Amen Protecting Tutankhamen* [16] was a gift of the architect Baron Alphonse Léopold Delort de Gléon at that same time.

The Era of Excavation Campaigns

As the twentieth century approached, important excavation campaigns were conducted in Egypt. Foreign missions obtained concessions, and the finds were officially divided. Strict regulation by the government had become a necessity because until that time each expedition had considered itself more or less the legitimate owner of its finds. The excavations of Emile Amélineau at Abydos (1895–98), for example, resulted in the discovery of the *Stele of King Serpent*, which had to be acquired by the Louvre at public sale in 1904. Most French excavations from that time on were carried out under the direction of the Institut français d'archéologie orientale du Caire (IFAO), created in 1880. These campaigns enriched the Louvre with objects from all the great sites of Egypt, belonging to all periods from protohistory through the Coptic period. The *Head of Djedefra, from a Sphinx* [3] comes from the excavations at the site of Abu Rawash, north of Giza (1907). The *Seated Statue of Sesostris III* [5] and the *Bust of Tuthmosis IV* [11] come from Nag el-Madamud, an ancient sanctuary north of Thebes. The temple there, dedicated to the war god Mentu, was covered with Coptic houses until the site was cleared between 1925 and 1933 by Fernand Bisson de la Roque, who found the statues beneath the walls. The *Relief of Tuthmosis III* [9] belongs to a group from the temple of Elephantine Island (excavations of Charles Clermont-Ganneau, 1906). The department was also enriched by Christian antiquities thanks to the excavations of Bawit (1901–13), which yielded parts of a church, and more recently of Kellia (1966–68), a monastic site in the Delta. Because of the growth of this Coptic collection, a semi-autonomous section linked with the Egyptian department was created.

The transfer of collections was another source of enrichment. In 1922 the Egyptian objects of the Cabinet des Médailles of the Bibliothèque Nationale were deposited at the Louvre. The *Bull Palette* [1], originally a gift of Tigrane Pasha to the Near Eastern department, came to the Egyptian department in 1912.

The Modern Era

The menace that weighed over Europe in 1938 led the curators to remove all Egyptian department objects and shelter them in various

chateaus. To Jacques Vandier,[10] responsible for the collections, fell the heavy task of putting everything back in place at the end of the war. In addition, he carried on a remarkable acquisitions policy.[11] At that time, the Egyptian museum took on its current appearance, in essence anyway. A few later modifications were necessary but limited by the lack of financial means.

The department has been considerably enlarged over the years. We forget sometimes that Champollion had at his disposal only the four rooms on the second floor (Musée Charles X). The Salle des Colonnes, in the middle of this long gallery, did not belong to the department until 1864, and the last rooms were not added until after the Second World War. In Champollion's time, the large objects were exhibited far away from the rest of the collection in the immense space then known as the Cour du Sphinx, now reserved for colossal Greco-Roman objects. The Galerie Henri IV was annexed in the middle of the nineteenth century. In 1904 the celebrated mastaba was installed near the Pavillon de Flore, joined later by the Coptic church from Bawit. The implementation in 1929 of Henri Verne's[12] expansion plan gave the department the ground-floor rooms (Aile de la Rivière) Champollion had coveted.

Even so enlarged, the department had become too small. Acquisitions have continued, though the division of finds from excavations gradually stopped after the 1960s. A few objects have come from the Sudan, a country where that prohibition took more time to be imposed. Enrichments have come from purchases, bequests, gifts (from individuals and from the Friends of the Louvre society), and the transfer of collections. In 1946 the Louvre had to absorb the Egyptian holdings of the Musée Guimet, no small affair. The 1500 objects given by the American collector Atherton Curtis and his family also came after the war. The *Pair Statuette of Amenhotep IV (Akhenaten) and Nefertiti* [14] is one of the jewels of this collection, as is the *Relief of a King, Probably Ramesses II* [18]. The Egyptian government, which now rightfully protects its patrimony, has nonetheless granted exceptions in special circumstances. The *Colossal Statue of Amenhotep IV* from Karnak (see p. 63) was a compensation for French participation in salvaging the Nubian monuments; a lot of objects from the IFAO excavations at Gebel Zeit was granted free of charge because the French company that had discovered the site while prospecting for oil then provided logistical support to the excavators.

Purchases, financed by the Musées Nationaux, must now be effected with great prudence, for the department will neither be an

accomplice to the inadmissible destruction of the architectural patrimony of Egypt nor encourage illicit excavations. Among the objects in this exhibition, the *Stele of Qahedjet* [2], the *Torso of Queen Sebekneferu* [7], the *Talatat: Amenhotep IV (Akhenaten) in Sed-Festival Costume* [15], the *Head and Torso of King Merenptah As a Standard-Bearer* [19], the *Head of Nectanebo I (Nakhtnebef)* [26], the *Stele Dedicated to Queen Cleopatra VII Philopator* [29], and the *Head and Torso of a Roman Emperor, Probably Nero* [30] have all been acquired since 1960.

For some years now, the department has been frustrated by lack of space, lack of means, crowded storage areas, the weight of tradition. But this era of enthusiasm and great hopes exemplified by the "Grand Louvre" project, largely already completed, will allow us to enlarge the department and remodel galleries completely, all the while respecting certain constraints imposed by the architecture of the palace. Let us hope that the museum visitors will contemplate in 1997 will be worthy of Champollion's superb gift.

NOTES

1. Auguste, comte de Forbin (1777–1841), French director-general of museums from 1816 until his death, went to Egypt to acquire antiquities for the Louvre.

2. François Sallier (d. 1831), French collector best known for the important papyri named after him (Sallier I-IV), now in the British Museum. He lived at Aix-en-Provence, where Champollion visited him in 1828 and 1830, on his way to and from Egypt.

3. Jean-François Champollion, *Lettres et journaux écrits pendant le voyage d'Egypte*, collected and annotated by H. Hartleben (Paris: Christian Bourgois Editeur, 1986), p. 153.

4. He read his ground-breaking *Lettre à M. Dacier . . . relative à l'alphabet des hiéroglyphes phonétiques* at the Academy of Inscriptions and Belles-Lettres in Paris on 17 September 1822.

5. Giovanni Battista Belzoni (1778–1823). Born in Padua, this one-time circus strong man and jack-of-all-trades excelled in the removal of colossal-size monuments. An intrepid explorer and excavator, he worked extensively at Abu Simbel and discovered the tomb of Seti I in the Valley of the Kings.

6. Charles, comte de Clarac (1777–1847), was curator of "antiques" from 1818 until his death.

7. Jean François Mimaut (1774–1837) was appointed French consul-general in Egypt in 1829. Through his influence with the viceroy, France obtained the Luxor obelisk now in the Place de la Concorde, Paris.

8. Georges Bénédite, "La formation du Musée égyptien au Louvre," *La revue de l'art* 43 (January–May 1923): 281.

9. The *Knife from Gebel el-Araq*, the *Statuette of Lady Tuy*, the statuettes of *Nebmerutef*, the limestone *Bust of Akhenaten*, the *Healing Statue*, among others.

10. Jacques Vandier (1904–1973) was head of Egyptian antiquities from 1944 until his death.

11. *Statue of Nephthys*, group of *Hemen and Taharqa*, *Statue of Hapdjefa*, *Stele of Qahedjet* [2], paintings from the tomb of Metjetji, *Papyrus Jumilhac*, among others.

12. Henri Verne (1880–1950), was director of the Louvre from 1926 until 1949.

Lawrence M. Berman Ancient Egypt abounded in images of its rulers. Those that survive—
and they survive in enormous numbers—are but a fraction of what
must have once existed. Colossal statues of the king fronted temple
pylons for all to see, statues lined processional ways and filled court-
yards and offering rooms to overflowing. These portraits came in all
shapes (seated, standing, kneeling, and, of course, sphinxes) and sizes
(tiny statuettes to well over life-size figures). Reliefs on temple walls
showed the ruler victorious over his enemies and offering to the gods,
who granted him everlasting life, stability, and dominion. Further,
devotional images of the king were set up in private houses; the divine
ruler was the cornerstone of Egyptian civilization, whose maintenance
depended on him.

How do we recognize a king in Egyptian art? We know him, first
of all, by his crowns and other regalia. The oldest royal crowns refer
to the two main geographical areas of the country. The White Crown
of Upper Egypt (the south) is tall and conical, with a bulbous top [2,
15, 22, 26]. The Red Crown of Lower Egypt (the north) is short in
front and tall in back, with a spiral filament that curves inward. Com-
bined, they form the Double Crown, or *pschent* [29]. From the New
Kingdom on, rulers often wore the helmet-like Blue Crown, or
khepresh [12, 14, 18, 21, 23]. The most frequent royal headdress, how-
ever, is the *nemes*, a headcloth, often striped, that falls behind the ears
and over the shoulders in front and is tied into a tail in back [3–8, 10–
11, 13, 17, 20, 27–28, 30].

The *uraeus*, or royal cobra, rears up on the king's brow, hood ex-
panded, poised to attack. For clothing, the monarch wears a variety of
kilts, usually pleated. The royal kilt par excellence is the *shendyt*, which
has a central tab hanging down in front [5–7, 28], but rulers also wore
a straight-bottomed ceremonial kilt, which may be tight fitting or
triangular in profile [2, 17, 22, 30]. A bull's tail often hangs in back
[2, 5]. Kings could carry other regalia such as a mace and staff [2] or
shepherd's crook and flail [13, 15].

But how do we identify a specific king? Trying to do so brings up
the issue of portraiture in Egyptian art, about which there is some
controversy.[1] Some scholars maintain that the conventions of ancient
Egyptian art preclude the existence of "true" portraiture. That de-
pends, of course, on how the term is defined. A traditional view holds
that a true portrait must "represent a definite person . . . with his dis-
tinctive human traits . . . in such a manner that under no circum-
stances can his identity be confounded with that of someone else."
Furthermore, "as a work of art, a portrait must render the personal-
ity, i.e., the inner individual, of the person represented in his outer

form."[2] These standards might be considered too rigorous and restrictive by art historians today and not entirely appropriate for royal statuary—which, as we shall see, has other aims—but because these ideas correspond to the accepted concept of a portrait, we may as well use them as a point of departure.

Egyptian art passes the first requirement, to represent a particular person, with flying colors. Sculptures, whether of royalty or commoners, were almost always inscribed with the titles and names of their owners, so there is no doubt they represent specific people. But what about their individual traits? Egyptian art has been described as hieroglyphic, a system of signs, like the written language.[3] A sign, once invented, becomes part of the vocabulary of artistic forms, a repertory of images. The use of signs, however, need not preclude likeness. No one can deny the Romans their portraiture. Yet even the most convincing Roman portrait, for example, may be described as "an interpretive ideogram," "a system of construction out of pre-existent and independently meaningful parts."[4] The careful manipulation of signs is a measure of their success. The art of every period has its vocabulary; otherwise, it would not be able to communicate. The problem is, we have adopted the Roman alphabet, whose signs we recognize (even if we do not always grasp their hidden meaning). So the Egyptian language, with its different signs, strikes us as foreign, hieroglyphic.

As for character, it is invisible, and its interpretation is highly subjective. The portraits of Akhenaten [13–15], for example, certainly have character, but what it is, at this remove in time, is hard to say. His image has elicited diverse reactions—people often respond negatively to it, which was surely not his intention.[5] We recognize character by signs and gestures that depend on a tacit understanding between the artist and viewer, which in turn is based on underlying cultural assumptions. In this sense, Egyptian art is no more hieroglyphic than any other. Even portraits of our own time are recognized as much by pose, dress, hairstyle, expression, and body language as by individual physiognomy. These aspects of portraiture are embedded in our culture and are quietly understood. In short, a portrait is a work of art. The modern conception of a "photographic" likeness, impartial and objective, does little justice to the art of photography (which has its own conventions and aspires to more than mere mechanical reproduction) or to portraiture.

Royal monuments were supposed to last an eternity. A king wanted to be identified with his works for all time. Sesostris I formally announced his intention to build a temple to the sun god in the following terms:

A king who is evoked by his works is not doomed. He who
plans for himself does not know oblivion, for his name is still
pronounced for it. What pertains to eternity does not perish.[6]

Kings were expected to show respect toward their predecessors'
monuments, as illustrated in the following passage from a Middle
Kingdom text in which a king instructs his son:

Do not despoil the monument of another,
But quarry stone in Tura.
Do not build your tomb out of ruins,
Using what had been made for what is to be made.

. . .

A goodly office is kingship,
It has no son, no brother to maintain its memorial,
But one man provides for the other;
A man acts for him who was before him,
So that what he has done is preserved by his successor.[7]

In reality, this noble advice was not always followed. The archaeologi-
cal record speaks for itself. The pyramid of Amenemhat I at el-Lisht,
for example, is built to an undetermined extent (demolishing the pyra-
mid would be the only way to find out exactly how much) of reused
material from Old Kingdom pyramid complexes at Giza and Saqqara.[8]
Temples were continually rebuilt and enlarged, as desired or needed.
The old statues and reliefs might then be recycled, the reliefs reused
in the foundations of the new structure [5, 9, 11, 17], the statues
reinscribed. This phenomenon is commonly known as usurpation,
although the term implies a degree of hostility toward the original
owner of the monument that was not always present. An image of
Hatshepsut could be transformed into an image of Tuthmosis III, or
Tutankhamen into Ay or Horemheb, simply by replacing the car-
touche identifying the king with another. Thus, the images continued
to function in a new environment. But not all kings were content with
that. Ramesses II, the greatest usurper of all, recarved not only the
names but also the faces and figures of statues of such earlier rulers as
Sesostris I and Amenhotep III (to name two of his favorites) so that
those images would be recognized by one and all—literate and illit-
erate—as himself.[9]

Clearly, the Egyptians were concerned with likeness. In ancient
Egyptian the most common word for statue (later for any likeness) is
tut, from the verb "to be like." A statue (often distinguished by type—
seated, standing, or with attributes) or, more often, a standing mummy

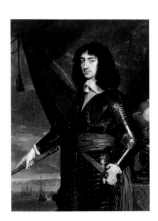

Charles II, King of England.
Oil on canvas, 129.5 x 97.2 cm
(51 x 38¼ in.), dated 1653.
Philippe de Champaigne,
French, born Brussels, 1602–
1674. The Cleveland Museum
of Art, Elisabeth Severance
Prentiss Fund 59.38

follows the word *tut* both as a noun and as a verb, thus underlining the concept of resemblance.[10] It may be argued that something other than physical likeness is meant.[11] More likely, it embraces both physical and spiritual likeness. Thus, images of deities are depicted with the features of the reigning king [16], who, in turn, is described as the image of god on earth.

Two additional factors must be kept in mind. One is the enormous time span involved—roughly three thousand years—during which changes in art, culture, and religion went hand in hand. The other involves the nature of royal portraiture in general, for at all times and in all cultures such depictions are not casual photographs but carefully crafted, officially sanctioned images. The question of what the ruler actually looked like is secondary. A king has to look like a king.

Consider the portrait of Charles II by Philippe de Champaigne in the Cleveland Museum of Art. Charles appears as a victorious ruler, according to the conventions of Baroque portraiture. He is presented in a three-quarter view, in armor, standing against a heavy gold curtain, with the blue ribbon of the Order of the Garter across his chest and a bright red sash around his waist. His left hand clasps the hilt of his sword; his right hand holds a baton. On a table to the right is a plumed helmet with a royal crown.

This is the Baroque equivalent of an Egyptian royal statue. All the accoutrements of majesty are there. The frontal pose is to Egyptian sculpture what the three-quarter stance is to Western painting. Substitute for the sword and baton a mace and scepter (or crook and flail), and you have a pharaoh.

The portrait was painted in 1653, when Charles, then twenty-three years old, was living in exile at Saint-Germain, outside Paris. The battleships and white cliffs of Dover in the background, however, proclaim his triumphal return to England, which did not take place until 1660 (and happened through the invitation of Parliament, not through naval conquest). But is it lifelike? Would we recognize Charles today, wigless and in blue jeans? We like to think so. Yet for many years the portrait was identified as James II, Charles's younger brother, painted by Peter Lely. It was not until the picture was cleaned in 1958, revealing the date, that the identification of the image as Charles II by Champaigne was established beyond doubt.

If such problems arise with a well-known seventeenth-century monarch, how do we stand with Egyptian rulers who died more than two thousand years ago? The answer is: fine. Egyptian kings do not all look alike. The features of Sesostris III [5], Amenemhat III [6],

Tuthmosis IV [11], Amenhotep III [12], and Akhenaten [13–15]—to name only a few of the rulers portrayed in this exhibition—are readily identifiable, and in most cases it is now possible to identify bodiless heads, even without inscriptions, as specific rulers. As in Western art, the problems that arise revolve around the presence or absence of identifying inscriptions or other documentation.

A limestone head, over life-size, in the Louvre has been variously identified as Sesostris III (Dynasty 12), Amenemhat III (Dynasty 12), or Sebekhotep II (Dynasty 13).[12] He wears the White Crown with uraeus and therefore must be a king. But which king? Amenemhat III can safely be ruled out because the head does not resemble him in the least [see 6] and he was not active at Nag el-Madamud, where it was found. Sebekhotep II's additions to that temple included a limestone portal decorated in sunk relief with scenes from his *sed*-festival, or jubilee. That relief is a direct copy of a portal of Sesostris III in every respect but the skill (or lack of it) of the carving, which is clumsy and flaccid where Sesostris III's is elegant and precise. The two portal reliefs are exhibited facing each other in the Cairo Museum and the contrast is startling.[13] It is hard to believe that Sebekhotep's sculpture in the round was of significantly better quality; however, the only securely identified statue of this king is headless and so affords no basis for comparison.[14] That leaves Sesostris III, who built the temple and left numerous statues there, including one in this exhibition [5]. Scholars have been reluctant to identify the head as Sesostris III because it does not exactly resemble his other statues. While the treatment of the eyes is different, the structure of the face and the vertical furrow of the brow clearly evoke the image of Sesostris III. The trouble is the material—limestone—for we know his image almost exclusively in hard stones. Sculptors using limestone may have worked in a different style than sculptors using granodiorite, for example, and other hard stones, but such an assertion is not possible to prove.[15]

Regardless of who the ruler is, we can say something about the statue's function and meaning. Two statue heads identical to the Louvre head were discovered at Nag el-Madamud, along with the body of a third.[16] They belong to series of colossal statues, originally 310 centimeters (about 10 feet) tall, showing the king standing, feet together, arms crossed over his chest, in the mummiform pose associated with the god Osiris. These so-called Osiride statues were placed architecturally: attached to pillars, around a courtyard, lining a passageway, or against the facade of a building. Osiris, the god of death and resurrection, was murdered by his brother Seth and brought back

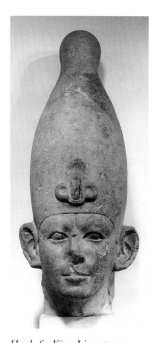

Head of a King. Limestone, h. 86.8 cm (33¾ in.). Nag el-Madamud. Middle Kingdom, Dynasty 12–13, perhaps reign of Sesostris III, 1878–1859 BC. Paris, Musée du Louvre, E 12924

to life by his sister Isis (the Greeks identified him with Dionysos, who returned from Hades). The imagery of these statues, strongly connected with regeneration and rebirth, is particularly appropriate in the context of the royal jubilee celebrating the renewal of the king's powers [see 15].[17]

A statue's meaning is enhanced through allegory. The king's divine nature may be emphasized by his pose (for example, Osiride) or by an item of apparel (for example, sun disk and ram's horns [9, 21]). Or he may forsake human form altogether. The Egyptians were ingenious in allegory, surpassing the most extravagant concoctions of later periods. Louis XIV may appear as Apollo and Napoleon as a nude athlete, but no Western ruler appears as a bull [1] or falcon [10]. By transcending physical reality, Egyptian art conveys associations and meanings beyond the capacity of the human figure.

NOTES

1. For recent discussions, see Claude Vandersleyen, "Porträt," *Lexikon der Ägyptologie* 4 (1980–82): 1074–80; Donald Spanel, *Through Egyptian Eyes: Egyptian Portraiture*, exh. cat. (Birmingham, Alabama: Birmingham Museum of Art, 1988), pp. 1–37; Andrey O. Bolshakov, "The Ideology of the Old Kingdom Portrait," *Göttinger Miszellen* 117/118 (1990): 89–142; Jan Assmann, *Stein und Zeit: Mensch und Gesellschaft im alten Ägypten* (Munich: Wilhelm Fink, 1991), pp. 138–68; Betsy M. Bryan, in Cleveland/Fort Worth/Paris 1992–93, pp. 125–29.

2. Bothmer 1960, pp. 117–18.

3. The locus classicus of this view is Alexander Scharff, "On the Statuary of the Old Kingdom," *Journal of Egyptian Archaeology* 26 (1940): 41–50. The "mimetic principle" discussed by Robert S. Bianchi, in Brooklyn/Detroit/Munich 1988–89, pp. 55–59, is a development of this idea.

4. Sheldon Nodelman, "How to Read a Roman Portrait," in Eve D'Ambra, ed., *Roman Art in Context: An Anthology* (Englewood Cliffs, New Jersey: Prentiss Hall, 1993), pp. 7–8, with respect to the Capitoline Brutus and the Prima Porta Augustus—two very different statues, but alike in their clever and deliberate manipulation of signs.

5. The destruction of Akhenaten's monuments did not begin until fifteen years after his death, in the reign of Horemheb, at the earliest, while the so-called Amarna style continued to influence Egyptian art into the Ramesside period.

6. From "Building Inscription of Sesostris I," trans. Miriam Lichtheim, in *Ancient Egyptian Literature: A Book of Readings*, vol. 1, *The Old and Middle Kingdoms* (Berkeley: University of California Press, 1973), p. 117.

7. From "The Instruction for King Merikara," in ibid., pp. 103, 105.

8. Hans Goedicke, *Re-Used Blocks From the Pyramid of Amenemhat I at Lisht*, Publications of the Metropolitan Museum of Art Egyptian Expedition 20 (New York: Metropolitan Museum of Art, 1971).

9. For Sesostris I, see Hourig Sourouzian, "Standing Royal Colossi of the Middle Kingdom Reused by Ramesses II," *MDAIK* 44 (1988): 229–54, pls. 62–75; for Amenhotep III, see Arielle P. Kozloff, in Cleveland/Fort Worth/Paris 1992–93, cat. no. 14.

10. See Bryan, in Cleveland/Forth Worth/Paris 1992–93, p. 127–28.

11. Boyo Ockinga, *Die Gottebenbildlichkeit im Alten Ägypten und im alten Testament*, Ägypten und Altes Testament 7 (Wiesbaden: Otto Harrassowitz, 1984).

12. Delange 1987, pp. 42–43.

13. Cairo, Egyptian Museum, JE 56497 A and 56496 A; Dietrich Wildung, *Sesostris und Amenemhat: Ägypten im Mittleren Reich* (Munich: Hirmer, 1984), p. 225, figs. 195–96.

14. Davies 1981, p. 23, no. 9.

15. A fragment of a life-size statue of Sesostris III in travertine, however, has all the hallmarks of Sesostris III's statuary in hard stone; see Josef Wegner, "Old and New Excavations at the Abydene Complex of Senwosret III," *KMT: A Modern Journal of Ancient Egypt* 6, no. 2 (Summer 1995): 67.

16. The heads are in the Egyptian Museum, Cairo, JE 54857 and 58926. The former is beautifully illustrated in Edna R. Russmann, *Egyptian Sculpture: Cairo and Luxor* (Austin: University of Texas Press, 1989), no. 35, pp. 78–79.

17. See Christian Leblanc, "Piliers et colosses de type 'osiriaque' dans le contexte des temples de culte royal," *BIFAO* 80 (1980): 69–89, pls. XIX–XXII.

A Note on Egyptian Royal Names

The king of Egypt had five names, each preceded by a title, that followed a strict order: Horus name, Two Ladies name, Golden Horus name, throne name, and birth name. The most important were the Horus name, written in a rectangle surmounted or preceded by a falcon, representing the god Horus; throne name; and birth name, the last two written in cartouches (ovals). Birth names often ran in families and were not unique. Thus, there were eleven kings named Ramesses belonging to Dynasties 19 and 20. The other names, adopted on coming to the throne, were different for each ruler. To avoid confusion, the Egyptians usually referred to their rulers by the Horus name or throne name, the latter often in combination with the birth name, rather than by birth name alone. In referring to pharaohs, modern historians generally follow a European custom that has nothing to do with ancient Egypt, using the birth name and a Roman numeral, Sesostris III [5], for example. The Egyptians would have referred to him using his throne name and birth name, Khakaura Sesostris.

The following chronology is based on Jaromír Málek, ed., *Egypt— Ancient Culture, Modern Land*, Cradles of Civilization (North Sydney: Weldon Russell, 1993), pp. 182–84. Dates are approximate before the Late Period. Catalogue numbers are provided for images of specific kings or images of unknown rulers from specific periods or dynasties.

[1] **Predynastic Period**
ca. 5000–2950 BC

Early Dynastic Period
Dynasties 1–2, 2950–2647 BC

Old Kingdom
Dynasty 3, 2647–2573 BC

Sanakht

Djoser

Sekhemkhet

Khaba

[2] Qahedjet, 2597–2573 BC

Dynasty 4, 2573–2454 BC

Sneferu

Cheops

[3] Djedefra, 2526–2518 BC

Chephren

Mycerinus

Shepseskaf

Dynasty 5, 2454–2311 BC

Userkaf

Sahura

Neferirkara

Shepseskara

Neferefra

Niuserra

[17] Menkauhor, 2377–2369 BC

Isesi

Unas

Dynasty 6, 2311–2140 BC

Dynasty 7, 2140–2134 BC

Dynasty 8, 2134–2124 BC

First Intermediate Period
Dynasty 9–10 (Herakleopolitan),
2123–2040 BC

Dynasty 11 (pre-unification),
2123–ca. 2040 BC

[4] **Middle Kingdom**
Dynasty 11 (post-unification),
ca. 2040–1980 BC

Mentuhotep II

Mentuhotep III

Mentuhotep IV

Dynasty 12, ca. 1980–1801 BC

Amenemhat I

Sesostris I

Amenemhat II

Sesostris II

[5] Sesostris III, 1878–1859 BC

[6] Amenemhat III, 1859–1814 BC

Amenemhat IV

[7] Sebeknefcru, 1805–1801 BC

Dynasty 13, 1801–1648 BC,
more than 50 rulers, including
[8] Sebekhotep IV, 1727–1720 BC

Second Intermediate Period
Dynasties 14–17, 1648–1540 BC

New Kingdom
Dynasty 18, 1540–1296 BC

Ahmosis

Amenhotep I

Tuthmosis I

Tuthmosis II

Hatshepsut

[9, 10(?)] Tuthmosis III, 1479–1425 BC

Amenhotep II

[11] Tuthmosis IV, 1401–1391 BC

[12] Amenhotep III, 1391–1353 BC

[13–15] Amenhotep IV (Akhenaten),
1353–1337 BC

Smenkhkara

[16] Tutankhamen, 1336–1327 BC

Ay

Horemheb

Dynasty 19, 1295–1186 BC

Ramesses I

Seti I

[18] Ramesses II, 1279–1213 BC

[19] Merenptah, 1213–1203 BC

Seti II

Amenmesses (usurper)

Siptah

Twosret

Dynasty 20, 1186–1069 BC

Sethnakht

Ramesses III

[20] Ramesses IV, 1153–1147 BC

Ramesses V

[21] Ramesses VI, 1143–1136 BC

Ramesses VII–XI

Third Intermediate Period
Dynasty 21, 1069–945 BC

Dynasty 22, 945–715 BC

Shoshenq I

[22] Osorkon I, 929–889 BC

Takeloth I

Osorkon II

Takeloth II

Shoshenq III

Pimay

Shoshenq V

Osorkon IV

Dynasty 23, 818–715 BC

Dynasty 24, 727–715 BC

Late Period
Dynasty 25, 715–656 BC

Dynasty 26 (Saite), 664–525 BC

Psammetichus I

Necho II

Psammetichus II

[23] Apries, 589–570 BC

[24] Amasis, 570–526 BC

Psammetichus III

[25] *Dynasty 27 (Persian), 525–404* BC

Dynasty 28, 404–399 BC

Dynasty 29, 399–380 BC

Dynasty 30, 380–343

[26] Nectanebo I (Nakhtnebef), 380–362 BC

Teos

[27] Nectanebo II (Nakhthorheb), 360–342 BC

Second Persian Period
342–332 BC

Greco-Roman Period
332 BC–AD 395

Macedonian Dynasty, 332–305 BC

Alexander the Great

Philip Arrhidaeus

Alexander IV

[28] *Ptolemaic Dynasty, 305–30* BC
Ptolemy I–XV, at times ruling jointly with their wives/sisters, including

[29] Cleopatra VII Philopator, 51–30 BC

Roman Empire, 30 BC–AD *395,* including

Augustus

Tiberius

Caligula

Claudius

[30] Nero, AD 54–68

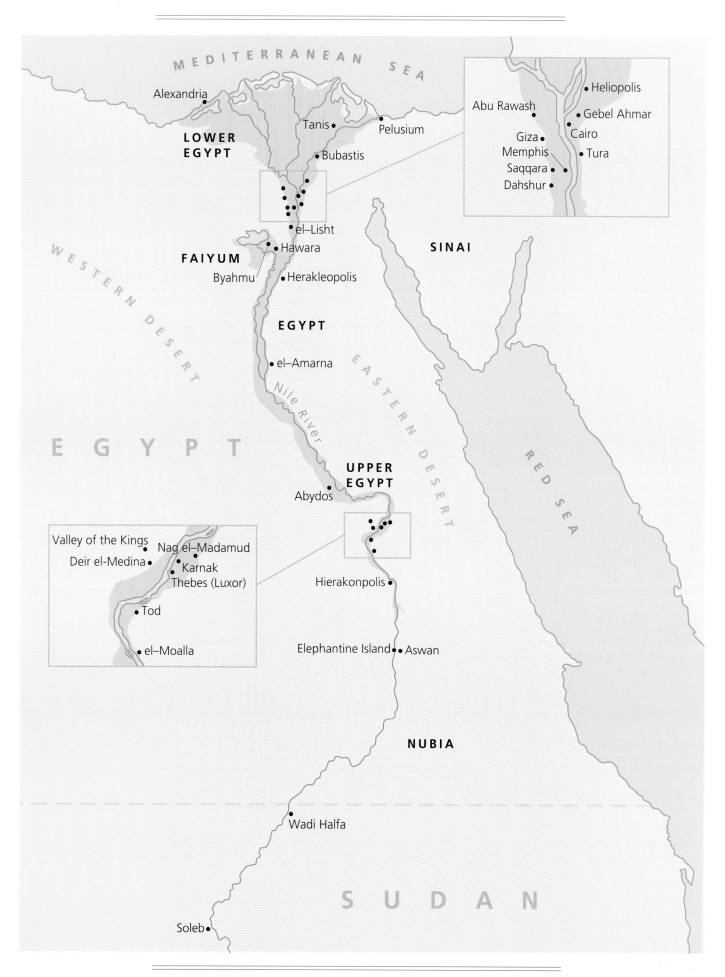

MEDITERRANEAN SEA

Alexandria

Tanis

Pelusium

LOWER
EGYPT

Bubastis

el–Lisht

FAIYUM

Hawara

Byahmu

Herakleopolis

EGYPT

el–Amarna

Nile River

UPPER
EGYPT

Abydos

WESTERN DESERT

EASTERN DESERT

SINAI

RED SEA

E G Y P T

Abu Rawash

Heliopolis

Gebel Ahmar

Giza

Cairo

Memphis

Tura

Saqqara

Dahshur

Valley of the Kings

Nag el–Madamud

Deir el-Medina

Karnak

Thebes (Luxor)

Tod

el–Moalla

Hierakonpolis

Elephantine Island Aswan

NUBIA

Wadi Halfa

S U D A N

Soleb

Mudstone; h. 26.5 cm (10¼ in.), w. 14.5 cm (5½ in.), d. 1.9 cm (¾ in.)

Late Predynastic Period, ca. 3000 BC

E 11255 = AF 1706

A god, the king of Egypt could appear in animal or part-animal form as a manifestation of his divine essence [see also 10]. The bull embodied strength and sexual potency, and from early times the king of Egypt wore a bull's tail as part of his costume [2, 5]. Later, the pharaohs of the New Kingdom regularly incorporated the element "victorious bull" in their royal titularies.

On each side of this shield-shaped ceremonial palette, the upper part depicts the king as a bull trampling an enemy. Below, on one side (facing page, right) are five standards: two surmounted by jackals, one by an ibis, one by a falcon, and one by the emblem of the god Min. Each terminates in a human hand grasping a rope. The standards, which may represent the various peoples or provinces united under the ruler, resemble the regional emblems of later times. They may also depict the deities who gave the king victory—Wepwawet, Thoth, Horus, and Min. At the bottom, the man's head with contorted arm and the leg above, perhaps from another figure, could be fallen enemies or prisoners. On the other side (facing page, left) are two towns, fortified enclosures with their names written inside, separated by a register line. Among the earliest examples of hieroglyphic writing, the words or phrases have not yet been deciphered.

The ruler is not named on the surviving portion of the palette, yet he cannot have lived much earlier than Narmer, whose palette in the Cairo Museum shows the king as a bull breaking through the walls of a city and trampling its inhabitants. Ceremonial palettes are generally believed to record the final stages in the unification of Egypt under one ruler in Dynasty 1, although their exact meaning and function remain elusive. They appear to have evolved from the geometric or animal-shaped cosmetic palettes used to grind eyepaint. The surviving ceremonial palettes have a circular depression on one side that may reflect such a purpose. Unlike the smaller cosmetic palettes, which have been found mainly in tombs, the large ceremonial palettes whose provenance is known have been found in temples, suggesting they were votive objects.

The *Bull Palette* is the finest in the series of ceremonial palettes. The way the sinuously curved horns and back of the bull form the outline of the palette is superb. The carving is exceptionally bold and imaginative, with various levels of relief. The bull's hoof exerts real pressure on the victim's leg, and the treatment of the men's hair and beards is detailed and delicate. LMB

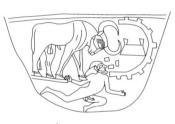

Palette of Narmer (detail). Mudstone. Hierakonpolis. Late Predynastic Period, ca. 3000 BC. Cairo, Egyptian Museum, CG 14716. Line drawing after W. M. Flinders Petrie, *Ceremonial Slate Palettes*, British School of Egyptian Archaeology 66 (a) (London: British School of Egyptian Archaeology and Bernard Quaritch, 1953), pl. K

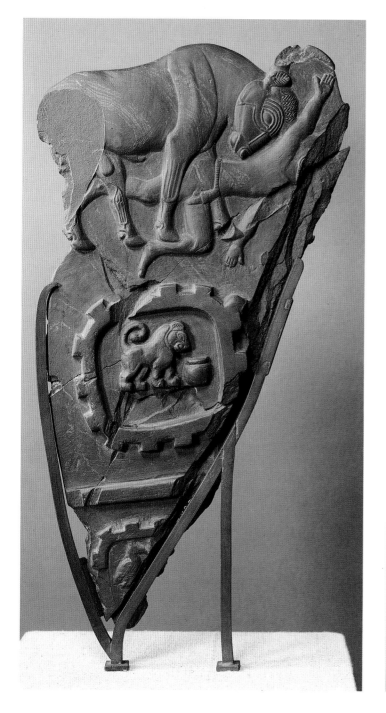

Limestone; h. 50.5 cm (19½ in.),
w. 31.3 cm (12¼ in.), d. 2.8 cm
(1 in.)

Old Kingdom, Dynasty 3, reign
of Qahedjet, ca. 2597–2573 BC
E 25982

One of the scenes often encountered on temple walls shows the king embraced by a divinity. Because the king is also a god, the two are on equal footing and the same height. This upright rectangular stele marks the first occurrence of such a scene and also introduces the god Horus as a falcon-headed man.

The king wears the White Crown and royal false beard attached to his chin by a strap. His costume consists of a tight-fitting corselet with shoulder strap, short kilt, belt, dagger, and bull's tail. He holds a staff in his left hand and a mace in his right. The falcon-headed god wears a wig and short belted kilt. Right hand on the king's shoulder, he clasps the king's arm above the elbow with his left. His legs and feet pass behind those of the king in the opposite direction, forming a pleasing pattern. The relief carving is very low and modulated by subtle gradations of the surface. As much attention is given to the markings of the falcon's head as to the features of the king. Incised detail has been reduced to a minimum, but where it occurs—notably in the wig and the bull's tail—it is fine and delicate.

Just as the figures of king and god face each other, so do their names. The ruler is identified by his Horus name, the first and oldest part of the royal titulary, which proclaims him as the earthly incarnation of the god of sun and sky. The name is the image of a falcon, the god Horus, perched on top of a rectangle, the lower part of which is decorated as a monumental palace gateway. Inside are the two hieroglyphs spelling the king's name, Qahedjet (*qa* meaning "high," *hedjet* "White Crown"). Thus, Qahedjet is the Horus whose White Crown is high. Facing him is Horus of Heliopolis, identified as "Horus in the Great Mansion." Heliopolis (Greek meaning "City of the Sun") was the principal sanctuary of the sun god. A temple stood there at least as early as the reign of Djoser, the second ruler of Dynasty 3, who built the Step Pyramid at Saqqara. Once a thriving metropolis, its ruins lie on the outskirts of Cairo.

The relief is dated by style to Dynasty 3 as the carving closely resembles the reliefs of Djoser's Step Pyramid, where the king appears in the same costume, holding staff and mace. The same low relief and sparing use of intricate detail occur also on the exquisite fragments from Djoser's temple at Heliopolis now preserved in the Egyptian Museum of Turin. Although the Horus name Qahedjet occurs on no other monument, he may be the same as Huny, the last ruler of Dynasty 3, who is known only by his birth name. LMB

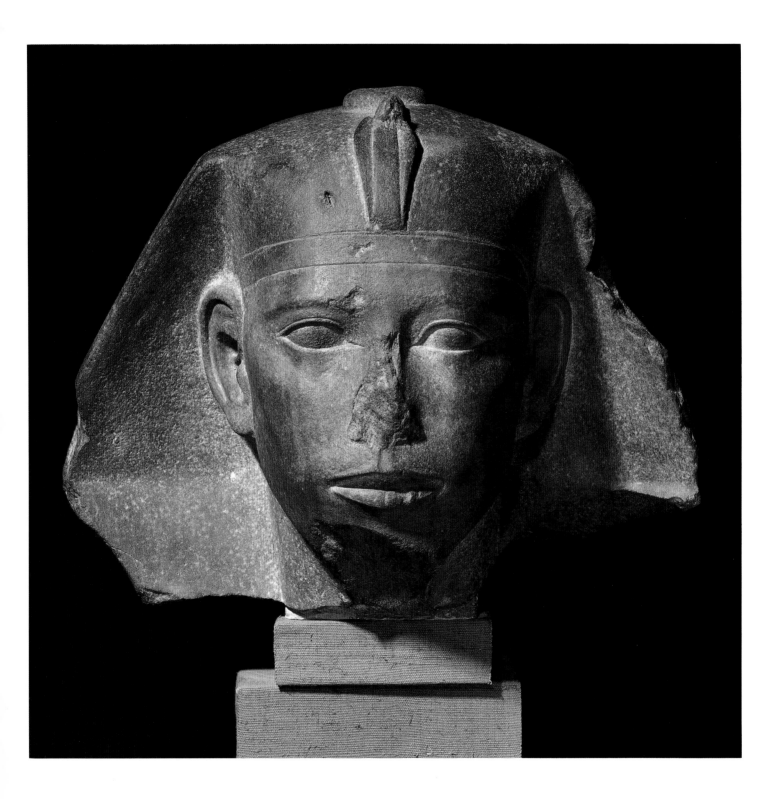

Red quartzite; h. 26.5 cm (10¼ in.), w. 33.5 cm (13 in.), d. 28.8 cm (11¼ in.)

Old Kingdom, Dynasty 4, reign of Djedefra, ca. 2526–2518 BC
E 12626

Head of Djedefra, from a Sphinx (side view)

Djedefra (also known as Radjedef) ruled between Cheops, builder of the Great Pyramid at Giza, and Chephren, builder of the Second Pyramid. For his pyramid, Djedefra chose the commanding plateau of Abu Rawash, about 8 kilometers (5 miles) north of Giza. Planned on a large scale, the site is devastated today because it was used as a quarry until modern times. Fragments of at least twenty-one royal statues, all of red quartzite, were found in the area of the temple on the east side of the pyramid. All had been smashed to bits. Luckily, a few larger fragments escaped further destruction because they ended up in the boat pit on the south side of the pyramid temple. Among them was this magnificent over life-size head, which ranks with the portraits of Chephren and Mycerinus as one of the greatest master-pieces of Old Kingdom sculpture.

The hard stone is worked with complete mastery. Bony and angular, the face has prominent jawbones and cheekbones as well as pouches under the eyes. The mouth is straight and wide. An impression of indomitable strength and determination arises from the tightly pressed lips and tensed muscles at the corners of the mouth. Similar features characterize two heads of Djedefra in the Egyptian Museum, Cairo—one in the White Crown, the other in the nemes—but neither attains the perfection of the Louvre portrait.

For the first time in sculpture in the round, the king wears the nemes-headdress and the uraeus. Traces of paint show that his skin was red and the eyebrows, borders of the eyelids, and cosmetic lines were black. The false beard has been lost, along with the chin, but part of the stone filling between beard and neck remains. The angle of the break at the back of the nemes indicates that the body was prone. It thus represented the king as a recumbent sphinx.

Djedefra's reign was short but full of innovations. Devoted to the sun god, he was the first ruler to call himself "son of [the sun god] Ra," which later became a standard element of the royal titulary. He was also the sole Old Kingdom ruler to use red quartzite for all his statues. The stone had solar significance, for its red color was associated with the sun, and its quarry, at Gebel Ahmar (Red Mountain) on the outskirts of Cairo, lay close to the sun god's principal sanctuary at Heliopolis [see 2]. LMB

Graywacke, cornea of limestone; h. 27.5 cm (10¾ in.), w. 22 cm (8½ in.), d. 22.3 cm (8¾ in.)

Middle Kingdom, late Dynasty 11 or early Dynasty 12, ca. 1999–1951 BC
E 10299

The line of kings ruling from Memphis (Dynasties 7–8) retained only nominal control of the country by the end of the Old Kingdom. They were succeeded by a family of kings ruling from Herakleopolis (Dynasties 9–10), who controlled the northern part of the country. The southern half was governed by virtually autonomous local rulers (nomarchs), who warred among themselves. This era is known as the First Intermediate Period. Gradually the southern part was consolidated under a Theban family, the Mentuhoteps (Dynasty 11), who around 2040 BC conquered the north and reunified the country. The last of the Mentuhoteps was succeeded by Amenemhat I, who founded Dynasty 12. He moved the capital back up north to a new town just south of Memphis, where he revived the Old Kingdom tradition of pyramid building. Amenemhat I's Horus name, Repeater of Births, proclaimed the beginning of a new era, the first renaissance in history. Dynasty 12 was later regarded as a golden age, the classical period of Egyptian civilization.

This portrait probably represents one of the last kings of Dynasty 11 or one of the earliest rulers of Dynasty 12, possibly Amenemhat I himself. The broad stripes of the nemes-headdress, position of the uraeus (above the bottom of the browband), small eyes, subtly modeled indentations at the nostrils, rounded cheeks, smiling mouth, and ball chin appear on one of the few surviving statues of this ruler. Similar features, however, are also found—though more often in isolation than together—in portraits of Mentuhotep III and Sesostris I (whose numerous statues exhibit an astonishing variety of facial types).

Although it is not possible to identify the subject precisely, it remains a vivid portrait, startlingly lifelike because of the inlaid eyes—limestone for the cornea, graywacke for the pupil. The contrast between the brilliant white limestone surrounded by the dark-hued graywacke is riveting. The eyebrows and cosmetic lines were also inlaid. The luminous polish, subtle modeling of the surface, and harmonious arrangement of the features, all characteristic of Middle Kingdom work, evidently appealed to the Egyptians of later periods, especially in Dynasty 26, for they recur in the *Head of a Saite Ruler, Probably Apries* [23], fourteen centuries later. LMB

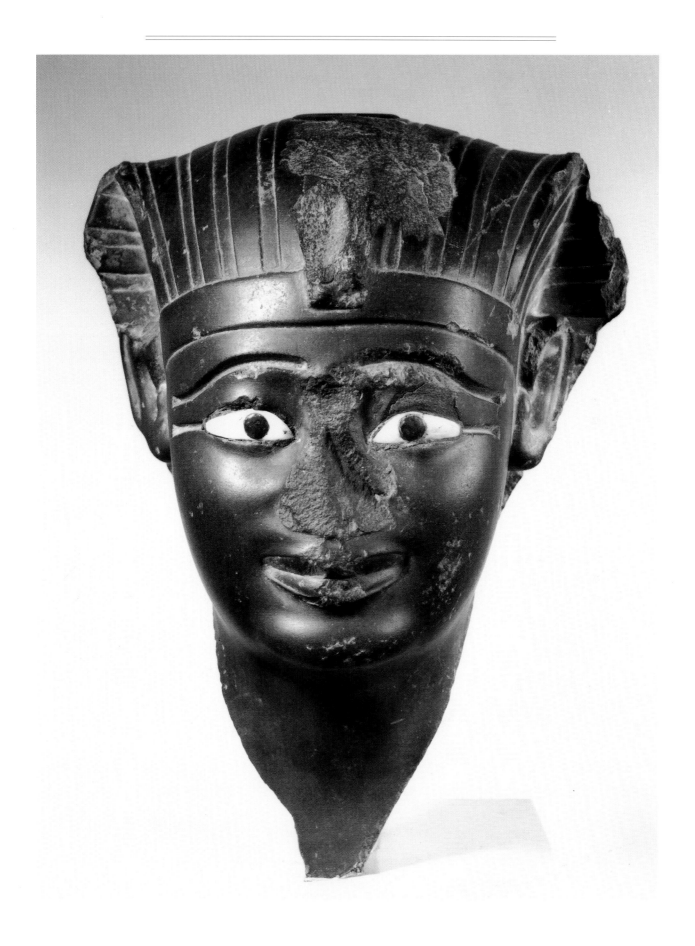

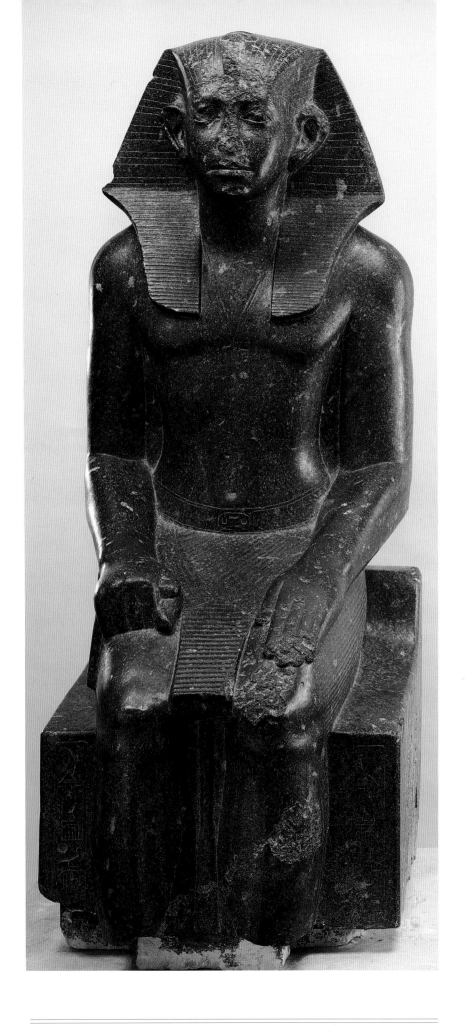

Granodiorite; h. 119.5 cm (46½ in.), w. 48 cm (18¾ in.), d. 46 cm (18 in.)

Middle Kingdom, Dynasty 12, reign of Sesostris III, 1878–1859 BC
E 12960 = E 14389

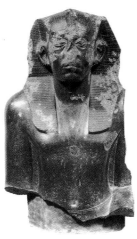

Bust of Sesostris III. Granodiorite, h. 79 cm (30¾ in.). Nag el-Madamud. Middle Kingdom, Dynasty 12, reign of Sesostris III, 1878–1859 BC. Excavations of Bisson de la Roque, 1925. Division of finds, 1927. Paris, Musée du Louvre, E 12961 = E 14392

Sesostris III, the fifth king of Dynasty 12, is renowned for his military campaigns in Nubia. He established Egypt's southern boundary at Semna, about 65 kilometers (40 miles) south of the modern border between Egypt and the Sudan at Wadi Halfa. There he set up his boundary marker, a red granite stele with the following inscription:

> The southern boundary made in regnal year eight under the Majesty of the king of Upper and Lower Egypt Khakaura, may he live forever and ever, so as not to allow any Nubian to pass it going north by land or by boat, or any cattle of the Nubians, except for a Nubian who shall come to trade in Iken or on official business.

Sesostris III's features, as revealed to us in more than one hundred portrait heads, are among the most striking and individual of any Egyptian king. Deep-set eyes with heavy eyelids, prominent cheekbones, a wide mouth turned down at the corners, and huge ears characterize his face. Here he sits majestically on a block-like throne with a low backrest. His left hand rests flat on his thigh, his right clasps a folded handkerchief. He wears the nemes-headcloth with uraeus, and around his neck hangs a pendant in the form of a bivalve clam shell. Otherwise he is naked to the waist, clad only in a shendyt-kilt with bull's tail. His throne name, Khakaura, is inscribed on his belt buckle. Two vertical inscriptions on the front of the throne give his Horus name, Divine of Transformations, followed on the left with his throne name and on the right with his birth name, Sesostris.

This is the best preserved and most youthful in appearance of a series of seated statues of Sesostris III from the temple of Mentu at Nag el-Madamud, 5 kilometers (3 miles) north of Karnak. Other faces of the king from this site depict him, to varying degrees, with a face lined as though with age and a morose, sullen expression, as though intending to show the king at different stages of life, from youth to old age. These so-called signs of age do not, however, affect the king's physique, which here as elsewhere is invariably firm and muscular. Moreover, Sesostris III was never really old. His father reigned only for eight years, Sesostris III for nineteen years. So, he was probably a young man at his accession. Because there is every reason to believe the statues were carved as part of the same project, the differences may be the result of different artists' interpretations of the royal visage, a tribute to the subtlety and invention of the sculptors of this time. LMB

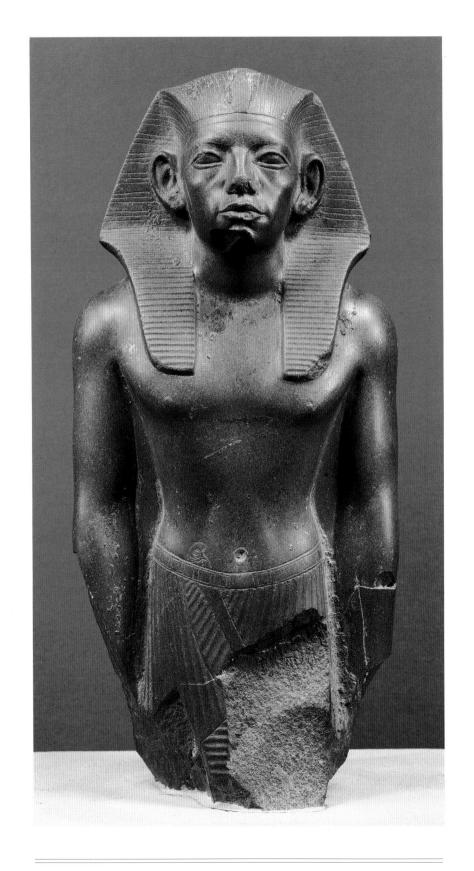

Graywacke; h. 21.4 cm (8¼ in.), w. 10 cm (4 in.), d. 10.3 cm (4 in.)

Middle Kingdom, Dynasty 12, reign of Amenemhat III, 1859–1814 BC
N 464

Amenemhat III, the son of Sesostris III, ruled for forty-five years. He was a prolific builder and patron of the arts. He had two pyramids, one at Dahshur and one at Hawara in the Faiyum, where he was buried. In front of the Hawara pyramid was his pyramid temple, the famous Labyrinth of the classical authors. The Greek historian Herodotus, who visited Egypt probably between 449 and 430 BC, marveled at it:

> I have seen this building, and it is beyond my power to describe; it must have cost more in labour and money than all the walls and public works of the Greeks put together. . . . The pyramids, too, are astonishing structures, each one of them equal to many of the most ambitious works of Greece; but the labyrinth surpasses them.

At Byahmu, overlooking Lake Qarun, Amenemhat III erected a pair of colossal seated statues of himself 12.1 meters (40 feet) high, made of solid quartzite, that rested on limestone pedestals 6.4 meters (21 feet) high. Today only the pedestals remain. Fortunately, however, many statues of Amenemhat III have survived, and they are among the glories of ancient Egyptian art.

Amenemhat III's features are as distinctive as his father's [5], and even though this statuette is uninscribed, there is no question as to its identity. He has large eyes with droopy lower lids, prominent cheekbones, a slightly aquiline nose—for once intact—large ears, and a distinctly sensual mouth, the upper lips describing a Cupid's bow. Parallel grooves run diagonally from the inner corners of his eyes, the wings of the nostrils, and the corners of the mouth, offset by a semicircular groove above the chin. The bunched-up muscles at the corners of the mouth and slightly protruding jaw help produce an impression of regal disdain.

The king wears the nemes-headdress with uraeus and is shown striding, left foot forward, arms at his sides. His firmly muscled body is clad in the pleated shendyt-kilt, showing off a slender waist. A dagger with falcon-headed pommel adds panache to the royal outfit. LMB

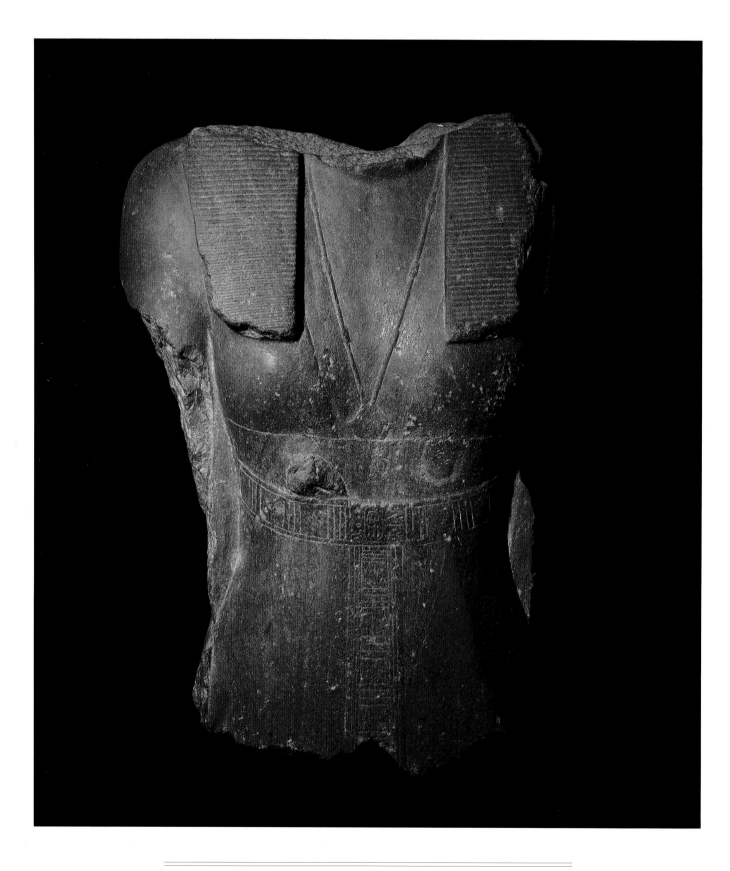

Quartzite; h. 48 cm (18¾ in.),
w. 33 cm (13 in.), d. 21.5 (8½ in.)

Middle Kingdom, Dynasty 12,
reign of Sebekneferu,
1805–1801 BC
E 27135

Sebekneferu, the last ruler of Dynasty 12, was the daughter of Amenemhat III. She succeeded to the throne after the death of Amenemhat IV, who was perhaps her brother, and reigned for exactly three years, ten months, and twenty-four days. She is one of a handful of women in ancient Egypt to rule as king. The others are Nitocris at the end of Dynasty 6, Hatshepsut in Dynasty 18, Twosret at the end of Dynasty 19, and Cleopatra VII—the last sovereign ruler of Egypt—in the Ptolemaic period. Hatshepsut and Cleopatra VII ruled the longest, but each nominally shared the throne with a male: Hatshepsut with her son Tuthmosis III, Cleopatra with her younger brothers Ptolemy XIII and XIV and her son (by Julius Caesar) Ptolemy XV Caesarion. Kingship in ancient Egypt was a male gender role. There was no Egyptian equivalent for the modern concept of ruling queen (the Egyptian term for queen, *hemet nesu*, means simply "king's wife"). Even Cleopatra VII, the famous femme fatale, appears as a bare-chested pharaoh when the situation demands it [29], as Hatshepsut almost always did. Sebekneferu is the exception, for in all of her statues that show her in human form she appears quite frankly as a female ruler.

This beautifully modeled torso is the best preserved of the five known statues of Sebekneferu (all without heads, including one sphinx), and still retains its allure. Only part of the nemes-headdress remains, and she wears the same shell-shaped pendant as Sesostris III [5]. Her costume cleverly combines female dress with kingly attire. Over a high-waisted shift with shoulder straps—the typical female dress—she wears a wraparound kilt with starched triangular panel in front—elements of male attire—complemented by a beaded belt and apron. The belt buckle inscription once again proclaims her femininity: "the daughter [of Ra?], of his body, Sebekneferu, may she live like Ra forever." LMB

Granodiorite; h. 124 cm (48¼ in.), w. 38 cm (14¾ in.), d. 69 cm (27 in.)

Middle Kingdom, Dynasty 13, reign of Sebekhotep IV, 1727–1720 BC
A 17 = N 17

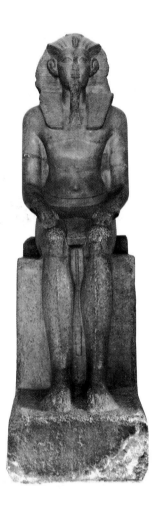

Colossal Seated Statue of Sebekhotep IV. Red granite, h. 275 cm (9 feet). Tanis. Middle Kingdom, Dynasty 13, reign of Sebekhotep IV, 1727–1720 BC. Acquired 1827, Drovetti collection. Paris, Musée du Louvre, A 16 = N 16

In most respects, the Thirteenth Dynasty was a continuation of the Twelfth, with the major difference the number of kings. During Dynasty 12, eight kings had reigned over 179 years; Dynasty 13 saw more than fifty kings over 153 years. Since their reigns were so short, few monuments survive from this period. Only seventeen rulers from Dynasty 13 are known from statuary, and, of them, only nine by statues with heads. Sebekhotep IV, the twenty-fourth ruler, is better represented than most. Nine of his statues have been identified, of which three have heads. Two are in the Louvre, one in the Egyptian Museum, Cairo.

Here Sebekhotep IV is seated on a block-like throne with a low backrest. He wears the nemes-headdress with uraeus and pleated kilt. Unlike the statue of Sesostris III [5], the belt is undecorated, there is no bull's tail, and both hands lie flat on the thighs. Two vertical columns of inscription adorn the front of the throne, and the hieroglyphs face inward. The texts are identical: "The good god, lord of the Two Lands, Khaneferra, the son of Ra, Sebekhotep, beloved of Hemen in Hut-Sneferu of Hefat." Hefat is the ancient name of el-Moalla, 39 kilometers (24 miles) south of Thebes. The closely connected town of Hut-Sneferu (modern Asfun) is 9 kilometers (5½ miles) farther south. Hemen was the chief god of both places.

The king's deep-set eyes, heavy upper lids, prominent cheekbones, downturned mouth, and enormous ears are reminiscent of Sesostris III [5]. Entirely his own, however, are the fleshy torso, thick arms, and elephantine legs. The statue is characterized by its asymmetry—the right side is higher than the left, which is particularly noticeable in the eyes, cheekbones, and nipples. A degree of asymmetry enlivens all Egyptian statuary, but rarely until the Ptolemaic period [see 28] is it as pronounced as here.

A comparison of this portrait of Sebekhotep IV with his colossal seated statue in the Louvre reveals less-pronounced asymmetry in a king with milder features, a narrower waist, and thinner arms, legs, and ankles. LMB

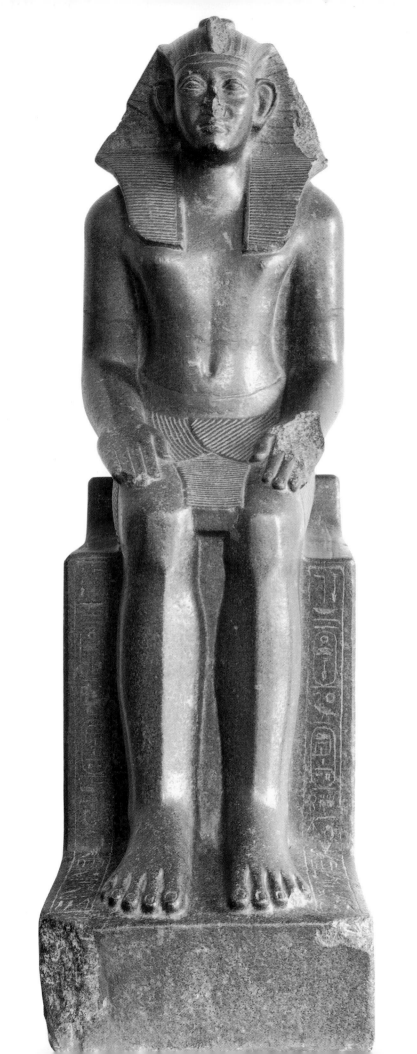

Painted sandstone; h. 67.5 cm
(26¼ in.), w. 108 cm (42 in.),
d. 18 cm (7 in.)

New Kingdom, Dynasty 18,
reign of Tuthmosis III,
1479–1425 BC
B 72 = E 12921 bis N

Because Tuthmosis III came to the throne as a child, his stepmother, Hatshepsut, assumed the reins of government, first as regent, then as full-fledged king beside him. The sixth ruler of Dynasty 18 spent the first twenty-two years of his reign in the shadow of his stepmother. Immediately after her death, he embarked on a series of annual military campaigns in western Asia—seventeen in all—that established his reputation as the greatest warrior pharaoh in Egyptian history.

This block of raised relief with its wonderfully preserved paint comes from the New Kingdom temple of the goddess Satis on Elephantine Island. Built during the joint rule of Hatshepsut and Tuthmosis III, it replaced an earlier Middle Kingdom structure and was itself replaced in the Ptolemaic Period by a new building. It is one of sixteen relief-decorated blocks from the New Kingdom temple that were found in the early 1900s by the French Institute of Oriental Archaeology in the foundations of the Ptolemaic temple. Those blocks, with the 350 discovered since 1969 by the German Archaeological Institute, make up roughly 40 percent of the original building, which has been reconstructed on the island using casts of the Louvre's blocks.

The king wears the _atef_-crown, an elaborate affair combining a tall central element resembling the White Crown with two ostrich plumes. Also on the crown are the long curved horns of a ram, sun disk and uraeus (in front), and a falcon with outstretched wings (in back). The falcon motif was a particular favorite of Tuthmosis III and frequently adorns his crowns at Thebes and other sites.

The royal profile, with its hawk-like nose, suits his bellicose image. He wears the straight-ended royal beard and, around his neck, a broad collar. At the upper right are the double cartouches containing his throne name, Menkheperra, and his birth name, Tuthmosis. LMB

Reconstructed temple of
Hatshepsut and Tuthmosis III
on Elephantine Island.

Red jasper; h. 11 cm (4¼ in.) New Kingdom, Dynasty 18,
 reign of Tuthmosis III (?),
 1479–1425 BC
 E 5351

From the front, this statuette of a ruler wearing the nemes-headcloth with uraeus is remarkable only for its small size, precious material, and beautiful workmanship. The back and sides reveal its true nature. We have already seen the king represented as a bull [1]; this statuette shows him as part man, part falcon, for the wings of a bird are folded over his back. From the position of his arms it may be inferred that he was either sitting or kneeling.

The falcon is the god Horus, lord of sun and sky, the god with whom the ruler was most closely identified from earliest times [see 2]. The image brings to mind the concept of the *ba*, an aspect of the soul that was depicted as a human-headed falcon, often with human hands. The ba was also regarded as the external manifestation of a deity. Thus, the king appears here as the ba of Horus.

The column of inscriptions on the front breaks off just short of identifying the specific ruler portrayed. It reads, "the king of Upper and Lower Egypt, the lord of action, [. . .]ra." As the name of the sun god Ra (written first because it is a god's name, but pronounced last) is a standard element of the royal prenomen, or throne name, it does not in any way narrow down the possibilities. Stylistically the head could represent either Hatshepsut (Maatkara) or Tuthmosis III (Menkheperra), whose images are frequently difficult to tell apart. The most likely candidate, however, is Tuthmosis III [9], of whom more small-scale statues exist than any other ruler of early Dynasty 18 and who, moreover, was very fond of falcon imagery [see 9]. Another ruler devoted to falcon imagery was Tuthmosis IV [11], but the facial features on this statuette preclude him.

Tuthmosis III extended Egypt's boundaries farther than any other king, from Syria to the Sudan. Likewise, the wingspan of the solar falcon (Behdety, equated with Horus) was believed to stretch from one end of the horizon to the other, bringing the whole world under pharaoh's dominion. LMB

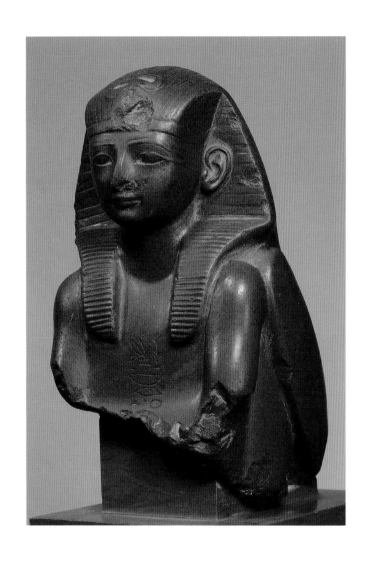

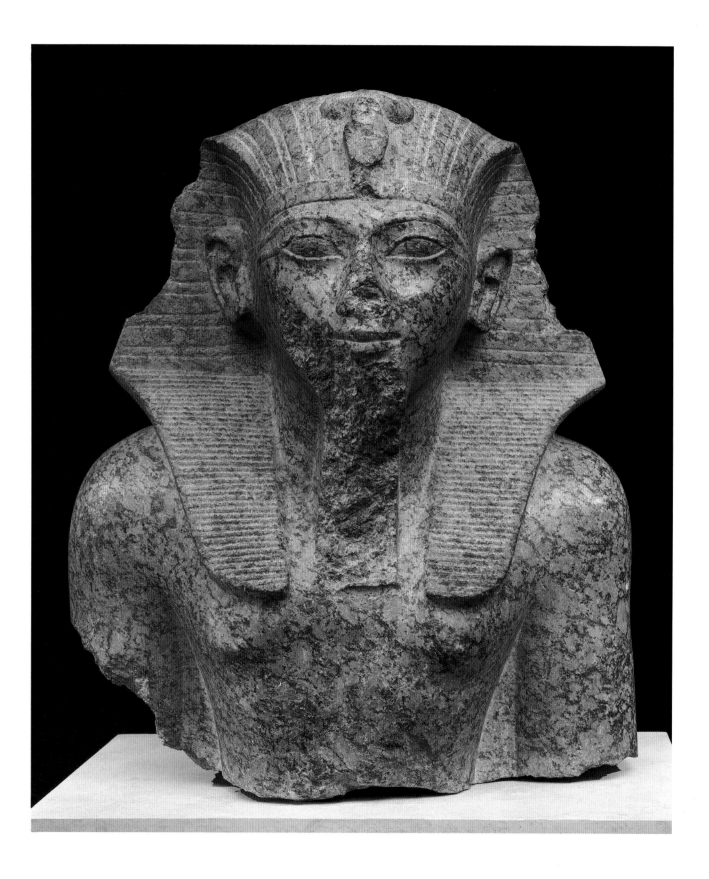

Red granite; h. 73 cm (28½ in.), w. 63 cm (24½ in.), d. 41 cm (16 in.)	New Kingdom, Dynasty 18, reign of Tuthmosis IV, 1401–1391 BC E 13889

The reign of Tuthmosis IV marked a turning point in the history of Dynasty 18. The age of military campaigning in western Asia, which characterized the reigns of his grandfather, Tuthmosis III [9], and his father, Amenhotep II, was over. Tuthmosis IV cemented a treaty with the kingdom of Mittani in northern Mesopotamia, Egypt's principal rival in the Near East, that divided Syria between them and began an era of peace that lasted through the reign of Amenhotep III into the reign of Amenhotep IV, when it was shattered by the rising power of the Hittites in Asia Minor.

Tuthmosis IV's best-known monument is the red granite stele, 361 cm (11 feet 7 inches) high, that stands between the paws of the Great Sphinx at Giza. There he tells how one day as a young prince he fell asleep in the shadow of the Great Sphinx, who spoke to him "like a father speaks to his son," promising him the kingship in return for clearing away the sand of the desert, which engulfed the enormous statue, then already eleven hundred years old, up to its neck:

> [Behold, my condition is like one in illness,] all my limbs being ruins. The sand of the desert, on which I used to be, faces me aggressively; and it is in order that you do what is in my heart that I have waited. For I know that you are my son and my protector.

As Egypt adjusted from a wartime to a peacetime economy, the image of the ruler also changed, as reflected in this bust of the king wearing the nemes-headdress with uraeus. A new sweetness pervades the royal visage, forecasting that of his son Amenhotep III [12]. The king has large almond-shaped eyes, set at an angle, high cheekbones, tapering jawbone, and wide smiling mouth. The pursed upper lip suggests an overbite, apparently a family trait, also present in the portraits of his son.

The statue comes from Nag el-Madamud [see 5]. The lower part, sadly battered, remains at the site but shows that the king was seated. LMB

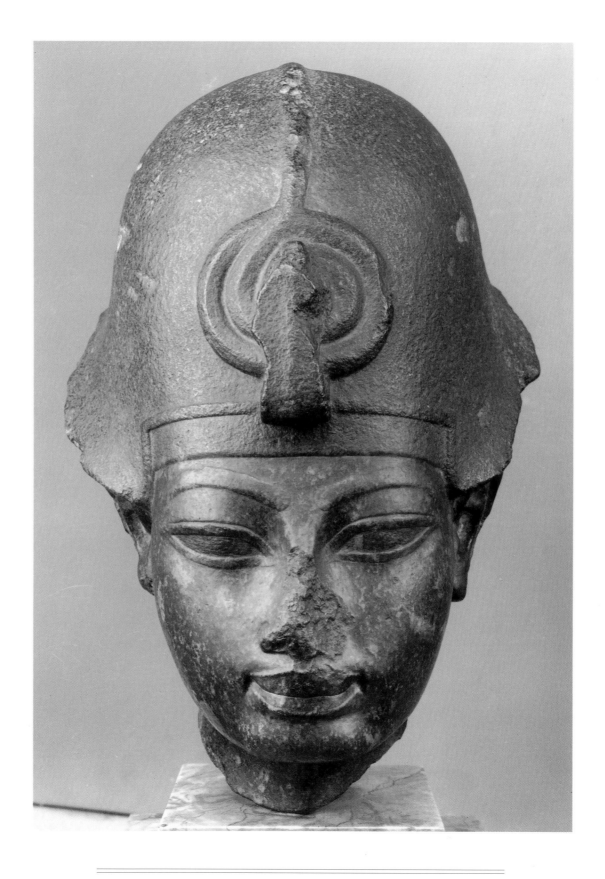

Granodiorite; h. 34 cm (13¼ in.),
w. 22.9 cm (9 in.), d. 25.3 cm
(9¾ in.)

New Kingdom, Dynasty 18,
reign of Amenhotep III,
1391–1353 BC
A 25 = N 25

During the long and peaceful reign of Amenhotep III, son and successor of Tuthmosis IV, Egypt reached the pinnacle of wealth and splendor. Trade flourished and gold poured in from the mines of the eastern desert and the Sudan. Luxor Temple, the Colossi of Memnon, and beautiful Soleb Temple in the Sudan are among the monuments conceived by Amenhotep III, the greatest builder and patron of the arts in Egyptian history. Yet he is not renowned only for the size and number of his accomplishments; his name is a byword for taste and elegance in all things, both large and small, and in every medium.

Head of Amenhotep III Wearing the Blue Crown. Granodiorite, h. 39.1 cm (15¼ in.). New Kingdom, Dynasty 18, reign of Amenhotep III, 1391–1353 BC. The Cleveland Museum of Art, gift of the Hanna Fund 52.513

This magnificent life-size portrait captures Amenhotep III's exotic features to perfection. His large almond-shaped eyes are thin and elongated, accentuated by thick cosmetic bands in relief and arched eyebrows tapering off to a point. His mouth is large and sensuous, with thick lips—the upper noticeably thicker than the lower—edged by a thin line.

A hallmark of Amenhotep III's statuary is the glistening polish of the hard, dark stone, exploited here to telling effect. The flesh areas, smooth as satin, form a dramatic contrast with the rougher surfaces of the eyeballs and the crown. The roughening on the crown may have had a practical purpose, for the crown may have been overlaid with another material that would adhere better to an unpolished surface. Although nothing remains to confirm this possibility, a portrait of Amenhotep III in Cleveland, where the Blue Crown has received a similar treatment, retains traces of painted resin indicating that the crown was painted blue with the browband in yellow. LMB

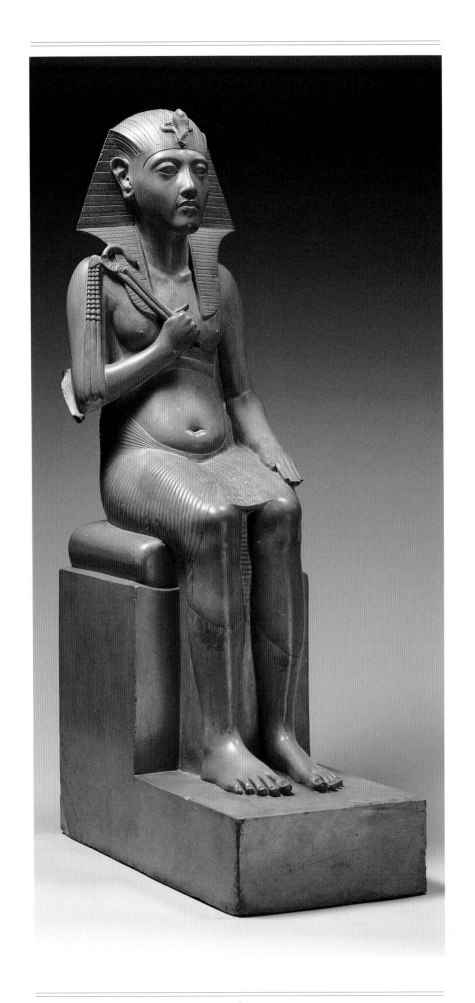

Yellow stone; h. 64 cm (25 in.), w. 17.2 cm (6¾ in.), d. 35 cm (13¾ in.)

New Kingdom, Dynasty 18, reign of Amenhotep IV/ Akhenaten, 1353–1337 BC

N 831 = AF 109

No king of ancient Egypt has so fascinated the modern mind as Amenhotep IV, better known as Akhenaten. Hailed by some (including Sigmund Freud) as the first monotheist, the precursor of Moses, he is decried by others as a religious fanatic. Still others view him as idle voluptuary, a dreamer who lost the Egyptian empire through indolence. He remains an enigma. The son of Amenhotep III, Amenhotep IV spent the first five years of his reign in Thebes. In his sixth regnal year he changed his name from Amenhotep (Amen is satisfied) to Akhenaten (Serviceable to the Aten) and moved to a new capital at el-Amarna, which he called Akhetaten (Horizon of the Aten), dedicated to the worship of the sun disk Aten. Elsewhere, the temples of the other gods were closed, their images destroyed, and their names hacked out of the walls. Even the word "gods" was expunged, for there was now no god but Aten. Akhenaten ruled for seventeen years. Shortly after his death, his successor Tutankhamen [16] restored the cults of the old gods, and Egypt returned to orthodoxy.

None of these facts was known when this most beautiful of all statues of Akhenaten entered the Louvre in 1826. The Egyptians had seen to that. Not a stone had been left standing of the king's vast buildings at Karnak [see 15] and el-Amarna, and his name had been excised from all records. When it was necessary to refer to him at all, it was as "that heretic of Akhetaten" or simply "the rebel." Gradually he was forgotten. The first European visitors to el-Amarna in the 1820s were fascinated by the relief-decorated private tombs in the cliffsides but were unable to read the mutilated name of the king. Today it is almost a household word.

This statue was probably carved late in the reign of Akhenaten, when the harsh style of his early years (see p. 62) had been tempered and restrained. The pharaoh slouches on a throne with a cushion, his left hand flat on his thigh, right arm bent, holding the crook and flail. He wears the nemes-headdress with uraeus and pleated kilt with bull's tail. His physique is anything but heroic: round shouldered, with sagging breasts, fat folds, and pot belly [compare 5]. Yet his face has an irresistible allure, with its dreamy expression, hooded eyes, and full, sensuous mouth. Characteristic of all Akhenaten's statues are the pierced earlobes, deep nasolabial lines, and fan-shaped navel.

Beautiful as it is, the statue is incomplete. The lower part has been restored, and originally the queen, probably Nefertiti [14], was seated on the king's right. Only her right forearm, wrapped around his back, remains. LMB

Painted limestone; h. 22.2 cm
(8½ in.), w. 12.3 cm (4¾ in.),
d. 9.8 cm (3¾ in.)

New Kingdom, Dynasty 18,
reign of Amenhotep IV/
Akhenaten, 1353–1337 BC
E 15593 = E 22746

This charming statuette, probably from a domestic shrine, shows
Akhenaten and his chief queen, Nefertiti (whose name means "the
beautiful one has come"), walking hand in hand. Both sport elaborate
floral collars, immaculate white linen garments, and sandals. The king
wears the Blue Crown with uraeus and pleated kilt gathered up at the
waist. Nefertiti wears her own flat-topped version of the Blue Crown,
made famous by her painted bust in Berlin, and huge ear plugs. Her
dress is cinched above the waist by a belt whose loose ends hang down
below her knees. Her body undulates beneath the rippled garment.
The well-preserved paint enhances the naturalistic effect, although the
traditional color conventions are observed, the king's flesh being
painted red, the queen's, yellow. The king is taller by almost a head;
otherwise, they strongly resemble each other, both in face and figure,
with sagging breasts (more noticeable in the queen's figure), fat stom-
achs, wide hips, formidable thighs, and spindly legs. The emphasis on
hips and thighs was doubtless meant to convey the fertility of the royal
couple, who are known to have had six daughters.

On the back, the name of the Aten (written in cartouches, like those
of the king and queen) precedes those of Akhenaten and Nefertiti.
The late form of the name—"Ra lives, the ruler of the horizon, rejoic-
ing in the horizon in his aspect of Ra the father who returns as the
Aten"—dates the statuette to after regnal year nine, when this form
was first adopted. LMB

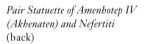

*Pair Statuette of Amenhotep IV
(Akhenaten) and Nefertiti
(back)*

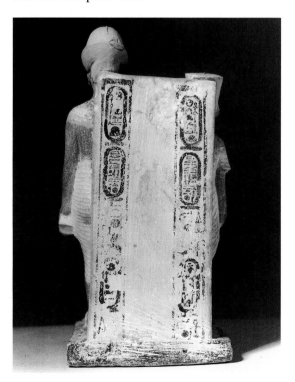

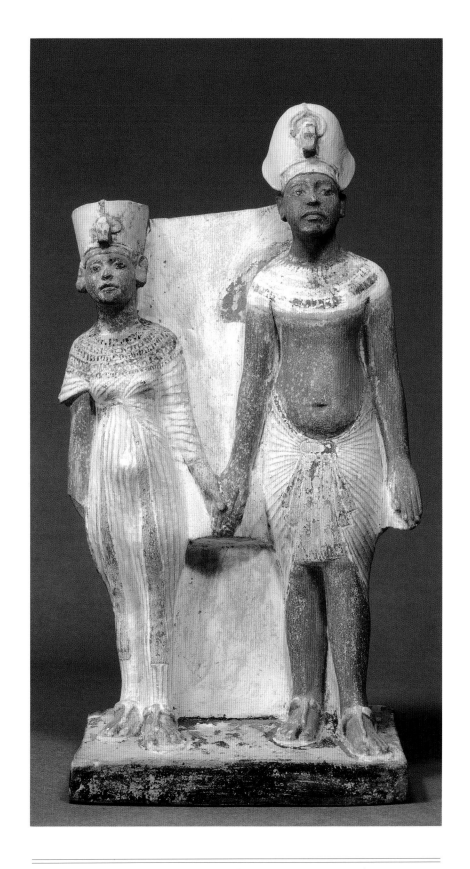

Sandstone; h. 11 cm (4¼ in.),
w. 25.2 cm (9¾ in.), d. 3.9 cm
(1½ in.)

New Kingdom, Dynasty 18,
reign of Amenhotep IV/
Akhenaten, 1353–1337 BC
E 26014

During the first five years of his reign, while still residing at Thebes
and before changing his name to Akhenaten, Amenhotep IV built an
enormous temple to the Aten, or sun disk, on the east side of the
temple of Amen-Ra at Karnak. To expedite construction, sandstone
was quarried in small, regularly sized, easily manageable blocks (not
the huge monoliths ordinarily used in temple construction) called
talatat. When that temple was dismantled after Akhenaten's reign, the
talatat were reused as filling material in other buildings at Karnak and
elsewhere. The building blocks of Akhenaten's temple were not re-
vealed until modern times, when the later structures began to fall
apart. Decorated in sunk relief, the talatat belong to at least four dif-
ferent structures. The largest, called Gempaaten (the Aten is found),
consisted of a huge open-air court about 130 by 200 meters (426 x 656
feet) surrounded by a roofed colonnade with colossal standing figures
of the king with arms crossed, holding the crook and flail. The rear
walls of the colonnade were devoted to scenes from the king's sed-
festival, or jubilee.

During this celebration, the king's powers were renewed and his
divine nature reaffirmed. Every king was entitled to at least one sed-
festival, ideally celebrated after thirty years of rule, with others ob-
served later at more frequent but irregular intervals. For example,
Amenhotep III celebrated three sed-festivals: the first in year thirty,

the second in year thirty-four, and the third in year thirty-seven. The next year he died. Ramesses II, who reigned for sixty-seven years, celebrated a record-breaking fourteen sed-festivals. Most kings, however, did not live that long and had to be satisfied with promises of "millions of jubilees" in the afterlife. Always the exception, Amenhotep IV celebrated his first (and probably only) sed-festival as early as his second or third regnal year (the exact date is not known).

In spite of the antiquity and importance of the sed-festival and the hundreds of references to it in royal inscriptions of all periods, few detailed records survive of the ceremonies. Amenhotep IV's are among the most detailed.

One of the scenes most frequently encountered in the talatat shows the king wearing either the White or Red Crown and the distinctive short sed-festival robe. Accompanied by priests, he visits a series of identical open-air shrines, presumably erected in the courtyard of Gempaaten, while the sun disk envelops him in rays ending in human hands. This block derives from just such a scene. The king wears the White Crown and holds an *awet*-scepter (resembling the crook but with a longer handle) and flail. Behind him is the bowed head of a priest with the title of "chamberlain and first prophet of [the king, referred to by his throne name] Neferkheperura-[Waenra]." The sketchiness, from the artist's unfamiliarity with the new style and rapidity with which he worked, would have been masked under a coat of painted plaster. LMB

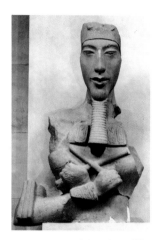

Colossal Statue of Amenhotep IV. Sandstone, h. 137 cm (54 in.). East Karnak. New Kingdom, Dynasty 18, reign of Amenhotep IV/Akhenaten, 1353–1337 BC. Paris, Musée du Louvre, E 27112

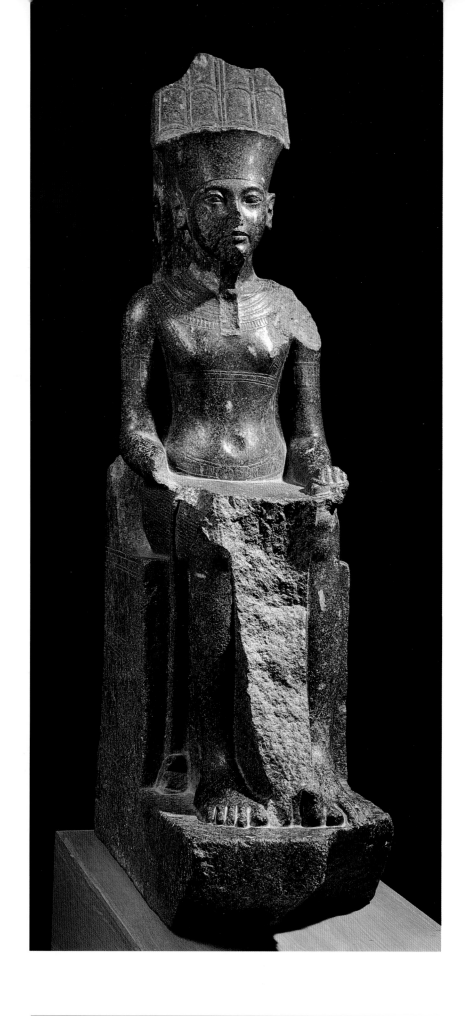

Granodiorite; h. 111 cm (43¼ in.),
w. 29 cm (11¼ in.), d. 70 cm
(27¼ in.)

New Kingdom, Dynasty 18,
reign of Tutankhamen,
1336–1327 BC
E 11005 = AF 779

Made famous by the discovery of his nearly intact tomb in 1922, Tutankhamen is nonetheless a mysterious ruler. The identity of his parents is uncertain, although he was probably born at el-Amarna, where Akhenaten attempted to impose his monotheistic revolution. Tutankhamen—hardly more than nine or ten years old at the time— inherited the throne after the disappearance of Akhenaten's ephemeral successor, Smenkhkara. Incapable of making his own decisions, Tutankhamen was taken in hand by the traditionalist clergy, who insisted that he re-establish the pre-eminence of Thebes and the cult of Amen. An edict carved in his name on a stele at Karnak attests to his works of restoration. He received no thanks for his piety, however, and a few years after his premature death at barely nineteen, he was grouped together with his heretic family. His memory was defiled by Horemheb, the royal scribe who had acted as his regent and who patiently waited until the end of the reign of Ay, Tutankhamen's successor, before finally seizing power.

At Thebes, Tutankhamen left many works of sculpture attesting to his devotion to the god Amen that have obviously been mutilated. This very beautiful work probably came from the site of Karnak. It represents Tutankhamen as a child, in reduced scale, under the protection of the triumphant god and was intentionally damaged. The names of the king on the back pillar were carefully hacked out in order to preserve the divine elements, Amen and Ra—parts of the king's name that, if destroyed, invited the gods' vengeance. The pose—the king standing between Amen's knees, facing him—is not common, and it has been reduced to the heels and the remains of one hand. Tutankhamen probably presented a platter of offerings to the god. Amen is presented here in his classical form—a human being wearing a false beard and a tiara surmounted with tall plumes that have not withstood the injuries of time. Heraldic representations of the interlaced plants of Upper and Lower Egypt appear on the sides of the throne. In front, in high relief close to Amen's right foot, is a complex emblem consisting of a plant stalk over a tadpole over a seal-ring (*shen*-sign), which the gods presented to the king to signify that they have accorded him longevity.

To be sure, the king's features are not preserved, but the god's features mirror them. The gentle, feminine face characterizes in a general way the portraits of Dynasty 18. The almond-shaped eyes, slightly projecting chin, and fleshy mouth correspond exactly to Tutankhamen's facial features as we know them. The king's youth as well as his obligation to erase his heretical past explain why he was represented in a humble attitude before his god. BL

Limestone; h. 95 cm (37 in.), w. 51 cm (20 in.), d., 17 cm (6½ in.)

New Kingdom, Dynasty 18, reign of Tutankhamen or later, 1335–1300 BC

B 50 = N 152 = N 5414 = E 3028

This well-preserved relief, originally part of a chapel built in the necropolis of Saqqara, was reused in the constructions of the Serapeum of Memphis. The chapel was dedicated by the physician Tjutju, who lived at the end of Dynasty 18, and this block was situated at the base of a wall. The upper register is reduced to the feet of the persons represented, but the two below are almost complete, or at least intelligible. The two very similar scenes are composed conventionally: humans (on the left) facing divinities, separated by a lotus floating above a ewer on a stand. The two men who raise their arms in adoration are one and the same person, the "scribe and physician, Tjutju." Above, he is followed by his wife, Nemau, and below, by his sister, Naia. Both women hold plants (probably papyrus) and wear shawls, with the traditional cones of perfume on top of their heads.

The divinities, male in the lower register and male and female above, are recognizable by their distinctive insignia—the scepter with the head of a jackal. The two gods, Duamutef and Qebehsenuef, represent half of a group of four funerary deities (the others are Hapy and Imsety) regarded as the sons of Horus. The goddess is Nephthys, sister of Isis. She wears her signature on her head; the same hieroglyphs spelling her name are repeated in one of the columns of text in front of her face. The fourth personage, who closes the procession at the lower right, is a king in ritual costume—dressed in the triangular kilt and wearing the nemes-headdress—and holding the crook of Osiris. Like the gods, in his left hand he holds an ankh-sign, symbol of life. The cartouche in front of his head gives his name, Menka(u)hor.

By no means contemporary with the people worshiping him in this scene, Menkauhor ruled in Dynasty 5 (2377–2369 BC). While he left few monuments, his pyramid is known from lists and most likely was located in the Saqqara necropolis. The name of Menkauhor (also called Ikauhor), is preserved in certain large royal lists of the New Kingdom (Abydos, Saqqara) but also in local lists found near the pyramid of Teti at Saqqara.

Many dead rulers were worshiped as gods, sometimes by the entire nation, sometimes in a particular place because the king was renowned there or because standing monuments recalled his memory to the populace. Sometimes this devotion focused on a famous statue preserved in a sanctuary. Clearly, in the New Kingdom Menkauhor received a cult at Saqqara, which is a good argument in favor of his having been buried there. Indeed, the officials who built their tombs or chapels at these venerated sites liked to put themselves under the protection of an illustrious ancestor of the region. BL

Painted limestone; h. 21.5 cm
(8½ in.), w. 50 cm (19½ in.),
d. 8.5 cm (3¼ in.)

New Kingdom, Dynasty 19,
reign of Ramesses II (?),
1279–1213 BC
E 22764

We know nothing about the original location of this beautiful block from a wall, which came from a private collection. In any case, it clearly dates from Dynasty 19, and we can assume it was part of the decoration of a temple built by Ramesses II, one of the most illustrious pharaohs of Egypt, because the king represented resembles him.

Carved in sunk relief, this image has traces of paint: brick-colored face, blue crown with yellow headband (now faded). What is left of the king's headdress indicates it was the ceremonial helmet known as the khepresh, with bulbous summit and a ribbon at the nape of the neck. Up until a few years ago, this headdress was regarded as a war helmet, but it is nothing of the sort. Rather, it is a parade headdress worn by the king in scenes where he is especially significant, participates in important ceremonies, or is represented in large scale or conspicuous places in architecture. He also wears it, however, when he is in his chariot. A magnificent representation in the court of Tuthmosis IV at Karnak shows the king, in heroic scale and wearing this crown, holding in his hands two enormous bouquets, hardly a war-like action.

Here, the king stands before a god whose image has totally disappeared. He seems to inhale a short stick of hieroglyphic signs (those visible stand for "life" and "dominion"), which float in front of his nose. These signs, untiringly repeated on temple walls, show the gods' promise to the king of longevity, health, and power.

The king's features are carved with remarkable finesse. The eye is slightly elongated, the nose aquiline. The face is idealized, to be sure, but it no longer has the feminine aspect characteristic of Dynasty 18 works. Note particularly the precise drawing of the ear and the expert modeling of the cheek.

The third ruler of Dynasty 19, Ramesses II enjoyed a long reign of sixty-seven years. He is famous for the Battle of Qadesh against the Hittites, which occurred in the fifth year of his reign. A treaty sealed by marriage in year twenty-one then ended the conflict. The other two-thirds of his reign were peaceful. Ramesses II was perhaps the first media king in history. His names appear everywhere, carved in sunk relief in enormous size, so that they are the first tourists identify when visiting Egypt. His architectural activity was prodigious, but he sometimes replaced his predecessors' names with his own on monuments and usurped their statues. In his defense, he did the same with his own images, often having them recarved more than once. BL

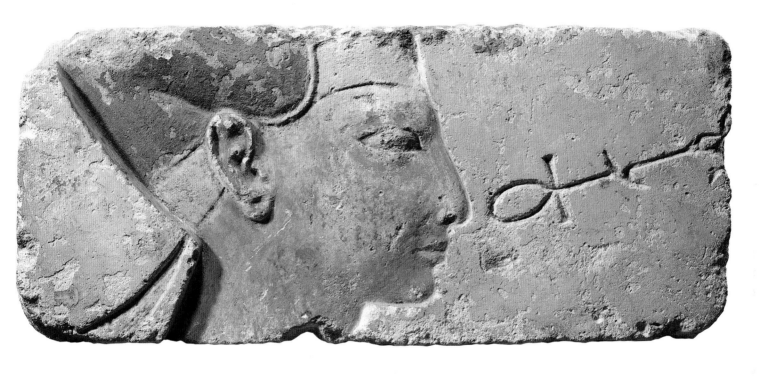

Travertine; h. 24 cm (9¼ in.),
w. 15.5 cm (6 in.)

New Kingdom, Dynasty 19,
reign of Merenptah, 1213–1203 BC
E 25474

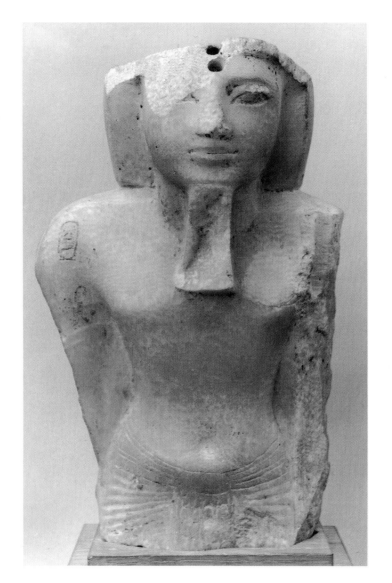 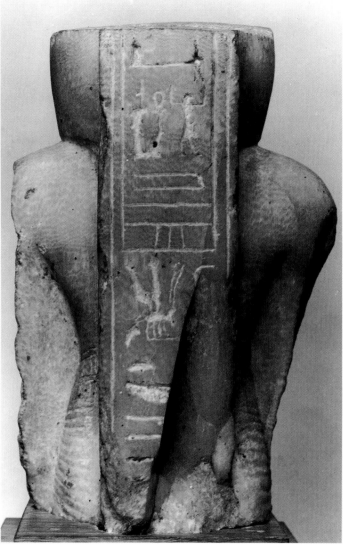

Ramesses II's many children were represented in processions on temple walls. These files of princes have established the order of their birth, making Merenptah the thirteenth son. Indeed, Ramesses II ruled so long and lived to such an old age that, when he died, the eldest princes had preceded him to the tomb. Merenptah (also called Mineptah), born to Queen Isetnefret, succeeded him and reigned only ten years. His time saw mounting danger from the outside. Migrant populations from the north, allied with Libyan tribes, threatened Memphis. He also had his troubles with Palestine and led an expedition against the Canaanite cities in this region. The stele relating these

deeds of war is famous, for the sovereign, in laconic terms, recounts that he has vanquished "Israel" and that nothing more remains of it! Interpreters of the Bible do not cease to evoke this event, for they wish to see in Merenptah's father, Ramesses II, the pharaoh of the Exodus. This is the only record of Israel in Egyptian texts.

Like his father, Merenptah usurped the statues of his predecessors, but with less zeal. The Louvre's statuette, which is certainly original, has no trace of hammering and thus is his alone. The theme of the standard-bearer, who could be a king or a private person, appears in Dynasty 18. The oldest certainly dated examples belong to the reign of Tuthmosis IV. The theme became fashionable in the second half of Dynasty 19. The standard is composed of a staff, generally cylindrical, surmounted by a head or statue of a deity. It was probably a cult object brought out from the sanctuary at the time of festival processions. The person who carried the standard could hold it in front of him or along his left arm (as is the case here) or even hold one against each shoulder.

When complete, but without the top part of the headdress, this statuette would have measured 55 to 60 cm (21½ to 23½ in.) tall. Traces of the staff of the standard are visible along the king's left arm. Cavities appear in various places: a perforation at the top of the head, on the leveled surface; a small hole at the edge of the headdress (the other hole in the middle of the forehead visible in the photograph was filled in with plaster in recent times); and finally, the scoring on the top of the broken staff. These openings prove that its upper part was hollowed out, leading to speculation that they may attest to ancient repairs, but that does not seem to have been the case. Rather, the upper part of the headdress (perhaps the Double Crown on top of the round wig), the uraeus on the brow, and the divine image on top of the standard were separate pieces made of stone or metal. Traces of blue pigment remain on the wig and in the hollows of the hieroglyphic signs, and traces of red are still visible on the torso. The king's titulary, inscribed on the back pillar, "Rejoicing in truth, the king of [Upper] and Lower Egypt, lord of the Two Lands," is interrupted by breaks. His usual name, Merenptah-Baenra, is emblazoned on his right shoulder. BL

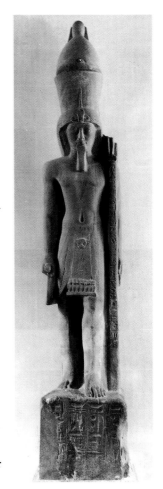

Colossal Statue of Seti II As a Standard-Bearer. Sandstone, h. 465 cm (15 ft.). Karnak. New Kingdom, Dynasty 19, reign of Seti II, 1200–1194 BC. Paris, Musée du Louvre, A 24

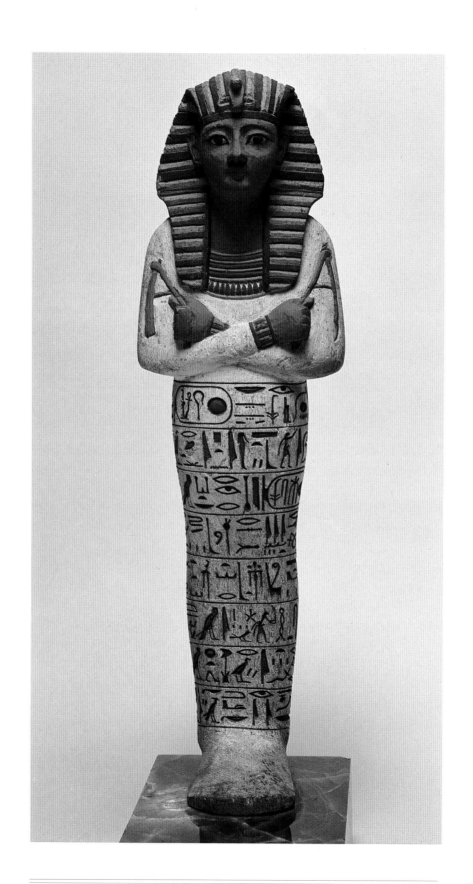

Painted wood; h. 32.5 cm (12¾ in.) New Kingdom, Dynasty 20,
reign of Ramesses IV,
1153–1147 BC
N 438

Most scholars believe that after the reign of Ramesses IV Egypt entered a period of relative decline. One Ramesses succeeded another until they reached number eleven. Most of our information comes from the economic and social spheres, thanks to the documents left by the workmen of the Theban necropolis. Ramesses IV continued his father's endowments to the temples and supported the royal artisans, increasing the number of workmen.

Small funerary figurines called *shawabtys*, also called *shabtys* and *ushebtys* (those who answer), represent the deceased in the form of a mummy. Only the headdress and the occasional hand-held accessories, along with a name, help identify the rank of the personage, royal or private. While shawabtys first appeared in the Middle Kingdom and were manufactured until the end of ancient Egyptian history, their origin is not royal. A text often inscribed on the body of the statuette indicates their function. This extract from *The Book of the Dead*, a collection of funerary spells for mainly nonroyal personages, enjoins the "double" (the figurine) to carry out the deceased's agricultural work and various other tasks he might be assigned in the afterlife. This type of forced labor would have been of no concern to the king, who after death joined the sun-god in his eternal revolutions around the Earth. Nonetheless, the shawabty of Ramesses IV carries the two hoes for breaking earth or mixing clay, and the extract mentioned above is inscribed in the king's name on the front of the legs. Thus all that distinguishes this shawabty from the figurine of a humble citizen is the nemes-headdress. From a substitute, the shawabty has become a simple servant, wearing like a livery his master's insignia. The colors have remained amazingly fresh on a brilliant white background. Although a stubborn tradition at the Louvre maintains that the paint has been retouched in modern times, many New Kingdom wood objects from the area of Thebes have this type of remarkable polychromy.

It so happens that Ramesses IV's shawabtys appear on the walls of his tomb in two rooms called treasuries. Lined up one behind the other, they are seen in profile, and number exactly forty. That figure is surprising, for a custom confirmed by a papyrus in the British Museum requires that such funerary workers should number 401: one for each day of the year (365), plus an overseer for every ten (36). Perhaps each of his shawabtys was intended to represent ten? The rule, however, was not always followed rigidly. Originally, the deceased had only one shawabty. In later burials, hundreds have been found for a single person, far surpassing the number 400. The fabulous treasure of Tutankhamen contained 417. BL

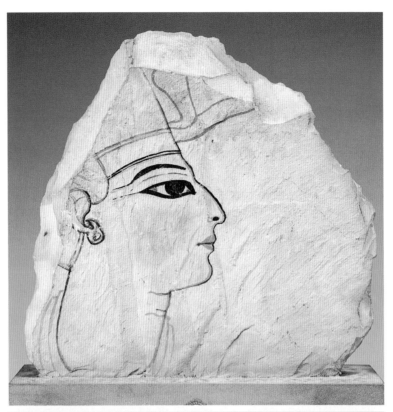

21. *Ostracon with Portrait of Ramesses VI*

Painted limestone; h. 21.3 cm
(8¼ in.), w. 22.5 cm (8¾ in.)

New Kingdom, Dynasty 20,
reign of Ramesses VI,
1143–1136 BC
N 498

This portrait was painted on a stone chip such as anyone might pick up in the Theban mountains opposite Luxor. The fine limestone of this geological formation breaks horizontally, forming flakes of this shape that are thicker in the center than at the edges. The ancient Egyptians who lived in this region, especially the officials and workers attached to the construction of the royal tombs of the New Kingdom, used them extensively as writing or drawing surfaces, without necessarily regularizing their shape. Thousands have been discovered that have drawings or texts, and similar objects of unknown provenance are automatically assumed to have come from Deir el-Medina, the modern Arabic name for the ancient village where the artisans lived. Such flakes are found scattered all over the Theban necropolis, as far as the Valley of the Kings. Egyptologists call them *ostraca* (singular, *ostracon*), from the Greek for "shell."

This one belongs to the category of figured ostraca. The draftsman did not even bother to smooth out the surface of the verso, on which is depicted a magnificent cobra representing Wadjet, protective goddess of the king and symbol of power over Lower Egypt. To the right is the back part of a royal head wearing a bonnet adorned with a ribbon at the nape of the neck. Not connected with each other, these motifs are probably trial pieces, either models that inspired the artists who decorated the royal tombs or sketches by students learning their trade. In this case, the artist who drew the head of a king on the recto had already attained a certain mastery, for the profile is a marvel. Sketched out in red, the draft was then partially gone over in black, with additional details appearing in yellow. The modeling of the cheek is suggested by a red shadow. The king wears the khepresh crown with uraeus [see 18]. Below the cobra is probably one of the two ram's horns that sometimes adorn the king's crown [see 9]. The artist has skillfully and realistically reproduced the facial features of what could be Ramesses VI—plump face with a powerful neck affected by wrinkles, heavy chin, aquiline nose, small mouth, and elongated eye. The earlobe is pierced.

Egypt under the reign of Ramesses VI was plagued by disorders. The king did, however, have a fine tomb in the Valley of the Kings. Several ostraca with the image of the ruler were discovered in his tomb, and this one doubtless comes from there. Funerary representations of the king—official images designed to assure his survival and perpetuate his memory—are idealized, with blander features. Free from such constraints in sketches like this one, artists could create works that approach the popular conception of a portrait. BL

Red granite; h. 140 cm (54½ in.), w. 90 cm (35 in.), d. 60 cm (23½ in.)

Third Intermediate Period, Dynasty 22, reign of Osorkon I, 929–889 BC

B 55 = E 10591

Reconstruction of scene. After Edouard Naville, *Bubastis (1887–1889)*, Egyptian Exploration Fund, Memoir 8 (London: Kegan, Paul, Trench, Trübner and Co., 1891), pl. XL. DE

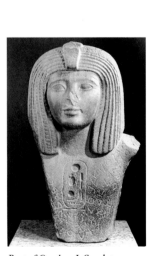

Bust of Osorkon I. Sandstone, h. 60 cm (23½ in.). From Byblos. Third Intermediate Period, Dynasty 22, reign of Osorkon I, 929–889 BC. Paris, Musée du Louvre, AO 9502

In 945 BC Libyan tribal chiefs seized power in Egypt and founded Dynasty 22, whose city of choice was Bubastis in the Delta. Because they assimilated Egyptian customs, there was no discernable upheaval. The first Libyan sovereigns respected tradition—as witnessed by this block—and assured Egypt a certain prosperity. Shoshenq I and his son Osorkon I were contemporary with the first kings of Judah (Rehoboam) and Israel (Jeroboam). David and Solomon were no longer of this world and the Hebrew tribes quarreled among themselves, allowing Shoshenq I to defeat the Israelites, a fact that the Bible freely admits, calling the pharaoh by name, Shishak (1 Kings 14:25–26). Shoshenq's successor, Osorkon I, maintained control over western Asia. The Louvre also owns a bust of Osorkon I found at Byblos that has a Phoenician inscription along with the Egyptian cartouche. Within Egypt, the clergy was powerful and remained so throughout the first millennium BC. The rulers had to reckon with them. Osorkon I kept up the temple domains and assured himself some control over the clergy by installing one of his sons as high priest of Amen.

This beautiful piece of granite was part of an ensemble, unfortunately dilapidated today, of blocks found in the first court of the Great Temple of the goddess Bastet, a lioness/cat, at Bubastis. It bears witness to the breadth of Osorkon's architectural projects. The Louvre's one block adjoins two others found in the same place, giving an idea of the complete scene. The king, in a conventional ritual pose, wearing the triangular kilt and bulbous White Crown adorned with a double ribbon, offers a statuette of the goddess Maat "to her father" (the god Amen-Ra, accompanied by his spouse [the goddess Mut], the gods of Thebes, and the gods of empire). Maat, whose name combines our ideas of truth and justice, represents the concept of natural order guaranteed by the action of the sovereign. The cartouches bearing the king's two principal names are inscribed in front of his headdress: Osorkon, beloved of Amen. The motif at the lower left is, in fact, the edge of a pile of offerings placed on two altars depicted on the neighboring blocks.

Despite rapid developments in the political world of Egypt, nothing had changed in matter of religion and decorative grammar. The king still has the aspect of a traditional pharaoh. The aesthetic is archaizing, inspired by the New Kingdom. The Libyan sovereigns also showed a particular admiration for the Ramessides, whose names they sometimes copied. BL

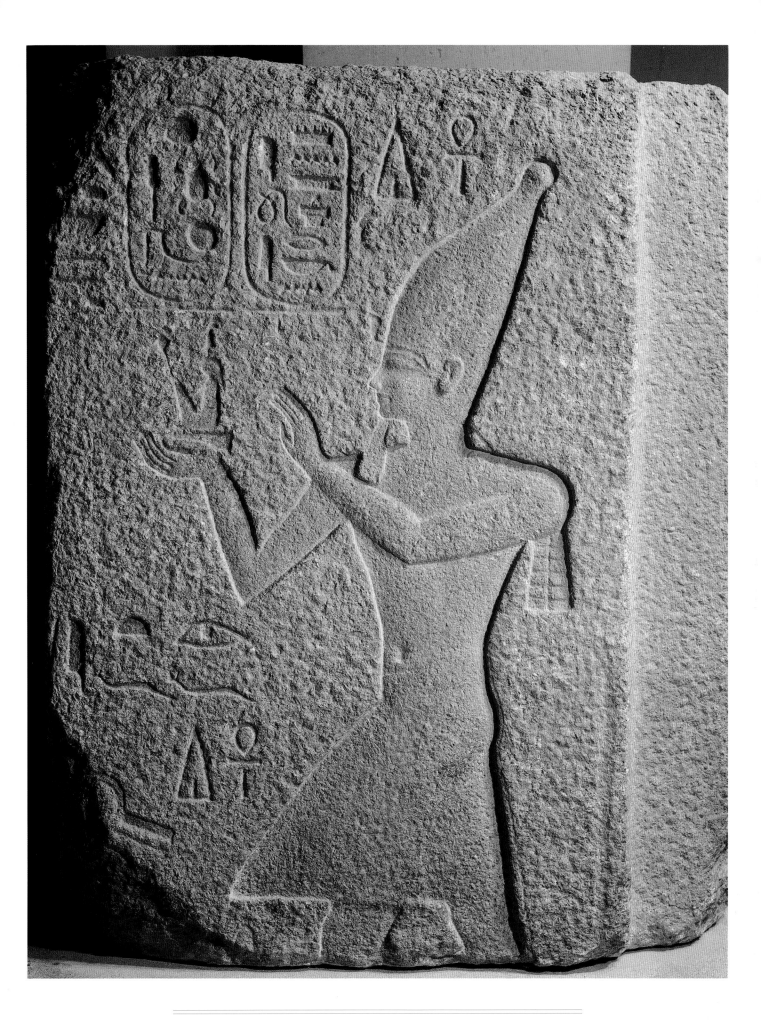

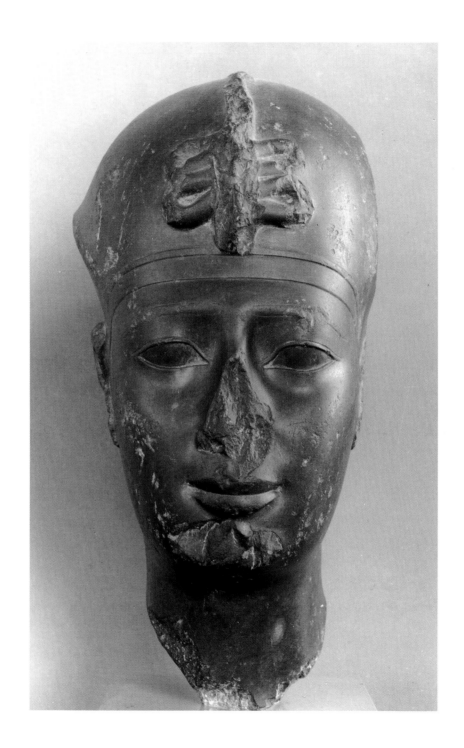

Graywacke; h. 36 cm (14 in.)

Late Period, Dynasty 26, reign of Apries, 589–570 BC

E 3433

By eliminating the foreign invaders, which put an end to a long period of successive occupations, the kings of Dynasty 26 restored a certain luster to Egypt. What is called the Saite Renaissance, named after its kings, was a period of openness to the Greek world and, at the same time, a return to the past. Old Kingdom works were copied, giving even the experts difficulty with attributions. Saite works are—quite rightly—always held up as models of archaizing art, but Egyptian art had relied on historical models for centuries, at least since the beginning of the New Kingdom.

While only the head remains of this statue, most experts agree, for stylistic reasons, that it is Apries. It is worked in greenish graywacke and highly polished. The Saites were enamored of smooth, brilliant surfaces and frequently used this stone.

Unfortunately, this head has been broken. The nose is missing, as is the left ear and adjoining area of the headdress, which has been planed smooth. The king wears the khepresh crown with the uraeus rearing up above the brow band, its tail winding up to the top of the crown. The ribbon is incised on the nape of the neck and the back pillar. The brow band, perhaps the edge of a protective cap between the head and the crown itself, thins out on the sides to disappear under the tab beside the ear. This detail occurs on other Saite royal heads but also appears later, under Nectanebo I (380–362 BC), and thus is not a criterion for dating.

The face, particularly the subtle modeling of the wings of the nose and the cheeks, is the work of a master sculptor. The raised eyebrows and the upturned corners of the mouth, giving the impression of a smile, are characteristic of the portraiture of this period. BL

Limestone; h. 107 cm (41¾ in.),
w. 63.5 cm (24¾ in.), d. 35 cm
(13½ in.)

Late Period, Dynasty 26,
reign of Amasis, 570–526 BC,
dated year 23
N 406

Sacred animal cults, which have a long history in Egypt, became very important during the Late Period. Because each god could incarnate himself as a species of animal, beasts of all sorts—dogs, cats, ibises, crocodiles—were protected, venerated, carefully mummified, and collected by the thousands in specialized cemeteries. But the sacred bull cults were of a different order.

A stele in the Louvre dating from the reign of Psammetichus I, the founder of Dynasty 26, mentions the renovation of the Serapeum of Memphis, the important ensemble consecrated to the Apis bull. Apis was the earthly manifestation of Ptah, the god of Memphis, as well as other deities. The bull on the upper part of this stele is described as "the son of Atum, wearing his two horns." Because Atum was a sun god, the bull is crowned with the solar disk. Apis was also associated with Osiris, in the form of Osiris-Apis, which the Greeks translated as Serapis, making him more a deity like Zeus, who was popular during the Ptolemaic and Roman periods. Apis was a god in his own right, and that is how he is presented on this stele.

The bull representing the deity was selected on the basis of precise physical characteristics, mainly concerning the hide. When the divine Apis died, a sumptuous funeral was arranged and the search for a successor began. Auguste Mariette found the catacombs of these sacred bulls in the Saqqara necropolis, each with its own chamber and enormous stone sarcophagus. The practice of setting up an epitaph stele at the death of an Apis began in the Saite period. The facts on these steles allow us to fix the chronology of the sovereigns with great precision, especially when an Apis spans the reigns of two kings.

This stele presents one of these epitaphs. The disposition of the motifs and texts is classical: at the top, beneath the lunette, is the winged sun disk, symbol of the solar falcon; below that, the generic scene in which the king worships the sacred animal; and at the bottom, the text specifying the intention of the ruler. The king kneels, in profile, his arms lowered in sign of adoration. The emblem behind him consists of the Horus falcon perched on a frame bearing one of the king's names atop a shaft provided with human hands and holding a scepter. The whole represents the king's *ka* (double). He is separated from the bull by an offering table, and the inscriptions beneath the disk identify both man and bull.

The carving of the hieroglyphs, clearly outlined in sunk relief, is remarkable. These pure lines are characteristic of the Saite style. BL

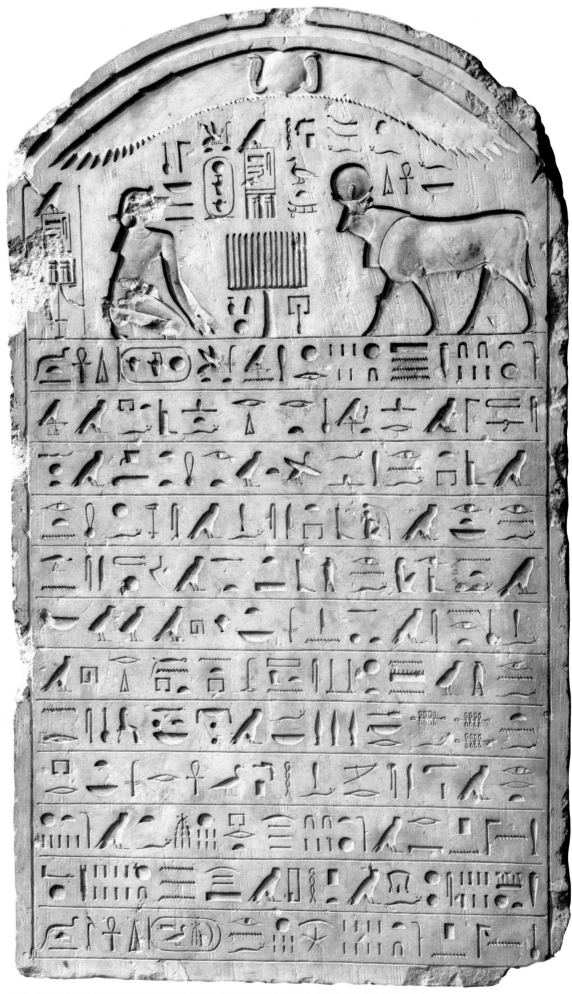

INSCRIPTION

Regnal year 23, the first month of Summer, day 15, under the Majesty of the King of Upper and Lower Egypt Khnemibra, given life forever:

Dragging the god in peace to the beautiful west, laying him to rest in his place in the necropolis,

in the place His Majesty had made for him, the like of which had never been done before, after

all had been done for him that is done in the place of embalming, for His Majesty remembered how

Horus had acted for his father Osiris, making a great sarcophagus of granite, for His Majesty found

that it had not been made in precious stone by any king of any time,

making a garment of mysterious fabric of Resnet and Mehnet, granting

him all his amulets and ornaments of gold and every precious stone, they being more beautiful than

what had been made before, for His Majesty loved the living Apis more than any king. The Majesty of this god went forth to

heaven in regnal year 23, the third month of Winter, day 6. He was born in regnal year 5,

the first month of Inundation, day 7. He was inducted into the house of Ptah in the second month of Summer, day 18. The beautiful

lifetime of this god was 18 years, 1 month, and 6 days. Amasis, given life and dominion forever, made [it] for him.

Translation by LMB

Limestone; h. 10.3 cm (4 in.),
w. 9.4 cm (3¾), d. 7.8 cm (3 in.)

Late Period, Dynasty 27
(Persian), 525–404 BC
E 14699

In the first millennium BC, Egypt learned that the outside world was no longer peopled by vassals or respectful allies. In 525 BC the Achaemenians arrived when Cambyses, a great king of Persia, defeated Psammetichus III at Pelusium and toppled the Saite dynasty. This first period of Persian rule would last until 404 BC. In the beginning, things did not go badly. The Near East had become cosmopolitan, and Egyptians, Near Easterners, and Greeks cooperated actively. Egyptian officials often collaborated with the new regime. Later, the situation deteriorated, especially when, after a short period of independence, Artaxerxes III reconquered Egypt (Second Persian Period, 342–332 BC). The Persians committed offenses that inspired revolts, and Alexander the Great easily conquered the exhausted country. The Persians' reputation was odious. A popular tale, which no doubt repeats malicious gossip rather than historical truth, reported that one of these rulers mistook the divine Apis for a beef bull and had it killed.

This little head, which clearly represents an Iranian, is believed to have come from Memphis, where such heads in Persian style have been found. In any case, no one—Egyptologists or specialists in the ancient Near East—disputes its Egyptian origin. The eyes are carved in the Egyptian style, and a similar though inferior head, also of limestone, was found in Egypt.

The man's long beard covers the entire lower part of his face below the nose. He wears a cylindrical diadem, and the roll underneath is not the brim of the headdress but his hair. The same headdress resting on a flattened mass of hair is found in Achaemenian reliefs.

Although his rank—king or high official—was in doubt in the past, specialists in the Near Eastern world today agree that this headdress can only belong to the Great King himself. British archaeologist William Matthew Flinders Petrie found a terracotta head of a Persian king at Memphis. Most likely the Louvre piece reproduces the stylized features of an Achaemenian ruler. BL

Red granite; h. 56 cm (21¾ in.), w. 22 cm (8½ in.), d. 34.5 cm (13½ in.)	Late Period, Dynasty 30, reign of Nectanebo I, 380–362 BC E 27124

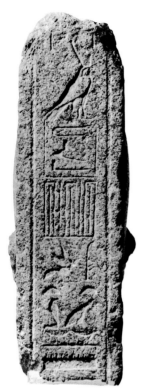

Head of Nectanebo I (Nakhtnebef) (back)

Before finally succumbing to the blows of its Mediterranean neighbors, pharaonic civilization experienced another renaissance under the last three sovereigns of Dynasty 30: Nectanebo I, Teos, and Nectanebo II. The two Nectanebos, falsely given the same Hellenized name, were actually called Nakhtnebef and Nakhthorheb. The two rulers are known from important constructions and restorations of Egyptian temples, notably monumental doorways and enclosures at Karnak. By its dimensions, this red granite head must have belonged to a statue just over life-size.

The back pillar is inscribed with the beginning of the titulary of Nectanebo I (Nakhtnebef). The rulers of Egypt had five regular names that could be augmented by numerous epithets in long inscriptions on temple architraves or appear in abbreviated form. An interesting detail appears on this head. The title of king of Upper and Lower Egypt, which usually precedes the king's throne name (the fourth in the series), here precedes the Two Ladies name (second in the series), which places the king under the protection of the vulture and cobra goddesses. The revival of this arrangement, which was normal in the Old Kingdom but rarely appears afterward, constitutes a deliberate archaism.

The king wears the White Crown of Upper Egypt with the uraeus. The facial features—nearly convex eyelids that give the eyes an Asian appearance, raised eyebrows, elongated eyes, smiling mouth—recall the Saite period [23]. It is true that, confronted with undated portraits, even the best archaeologists hesitate to chose between Dynasty 26 and a later date. There is, however, a criterion by which a head may be attributed to Dynasty 30: the height of the skull, making the face appear relatively slender. This stylistic detail can be hidden by an imposing crown, but here the surviving elements of the titulary on the surface of the back pillar are enough to identify the ruler. The face is conventional and does not resemble some of the same king's other portraits, where the chubbiness of cheeks and chin, barely suggested here, is very pronounced. BL

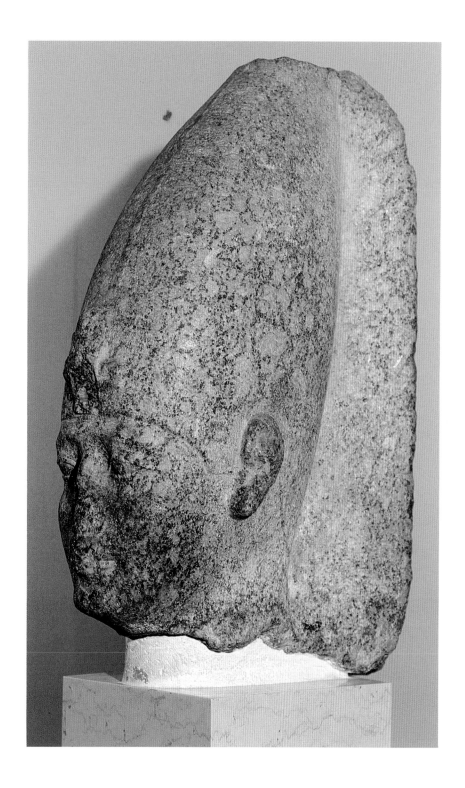

Limestone; h. 40 cm (15½ in.),
w. 63.5 cm (24¾ in.), d. 9.5 cm
(3¾ in.)

Late Period, Dynasty 30, reign
of Nectanebo II, 360–342 BC
N 423

Nakhthorheb, second successor of Nectanebo I, appears here performing a rite illustrated in Egyptian temples of all periods and always in the same manner, as the iconographic conventions of these religious scenes was very stable. Although the lower part of the scene is missing, it is easy to picture the king's pose and the accompanying hieroglyphic inscription. The ruler, arms at his side, faces the god Apis, identified by the hieroglyphic text above his horns as "the living Apis, herald of [Ptah]." Rather than as a bull [compare 24], the god appears here with the head of a bull and the body of a man. This combination, which ought logically to produce a monstrous image, is not shocking because the sculptor has cleverly used a wig (behind the horns and ear) to mask the transition from animal to human. This image confirms that the Apis bull had become a god in his own right, not just a sacred animal subordinated to a god. The god holds in his right hand the scepter terminating in a crook, emblem of Osiris. In this type of scene, the god usually carries a jackal-headed staff [17].

The king, identified by his principal names (enclosed in the cartouches in the center), is under the protection of the solar disk, two cobras coiling around it, crossing two ankh-signs. This heraldic emblem represents Behdety, the falcon as sun and sky god. In later periods, this motif tends to replace the more classical scene of the bird of prey flying above the king and enclosing his head with its wings spread at right angles.

The rite performed by the king is that of "adoring the god [four times]." The god's response to this greeting is written in a short column of text above and to the left of Apis: "I have given to you all life and dominion."

The king looks like a Nectanebo. His forehead is high, and the back of this skull, judging by the form of the headdress, is flat. The cheeks are fleshy, the chin heavy, and the neck powerful. The carving in sunk relief is careful, but because the contours are so precise, the figures seem lifeless. BL

Basalt; h. 82 cm (32 in.), w. 39.5
cm (15½ in.)

Greco-Roman Period, Ptolemaic
Dynasty, first century BC
A 28 = N 28

Head and Torso of a Ptolemy
(back)

After the earthquake caused by Alexander the Great, the successors of the Macedonian conqueror in Egypt, the Ptolemies (305–30 BC), accelerated the Hellenization of the country. The Greeks settled in the countryside and assimilated themselves fairly well, but their princes lived in Alexandria and followed Greek customs. They did, however, support and flatter the clergy, who retained a great influence over the populace, and used them to impose Hellenistic propaganda, representing themselves as gods. The Egyptian clergy, more and more atrophied and cut off from reality, secluded themselves in the temples, which became conservatories of pharaonic tradition, and represented the Greek rulers on temple walls and statuary as though they were Tuthmosis or Ramesses.

We do not know the identity of this king. The back pillar of this statue has no inscription, but its form—terminating in a pointed top superimposed on a rectangular surface—is hardly classical. There is no doubt, however, that the figure represents a Ptolemy. He is shown in a stiff, frontal attitude and dressed "à l'égyptienne," wearing the royal kilt and nemes-headdress with uraeus, which even in the pharaonic period, were not items of everyday dress as much as ritual costume. One detail appears as a sign of the times, the tendency to place the border of the nemes higher up on the head, or at least to have it describe a more pronounced arc, revealing more of the forehead. On the portraits most affected by Greek influence, and especially in the Roman period [30], even curls of hair were allowed to emerge from under the band.

The juvenile impression given by the wide face and smiling mouth is accentuated by the treatment of the eyes. The Late Period taste for perfectly polished stones is continued, and the smooth surfaces of the clothing, unmarked by pleats or other accessories, is a hallmark of the Ptolemaic style.

This statue is difficult to date with precision. The specialists in Ptolemaic art argue that the height of the head and the asymmetrical elements (the top of the headdress is higher on the left than on the right, as is the browband, exposing more of the forehead; the eyes and cheekbones are at different levels; the left side of the torso is wider than the right; and, in back, the belt of the kilt is higher on the left than on the right) suggest a date as late as the first century BC. BL

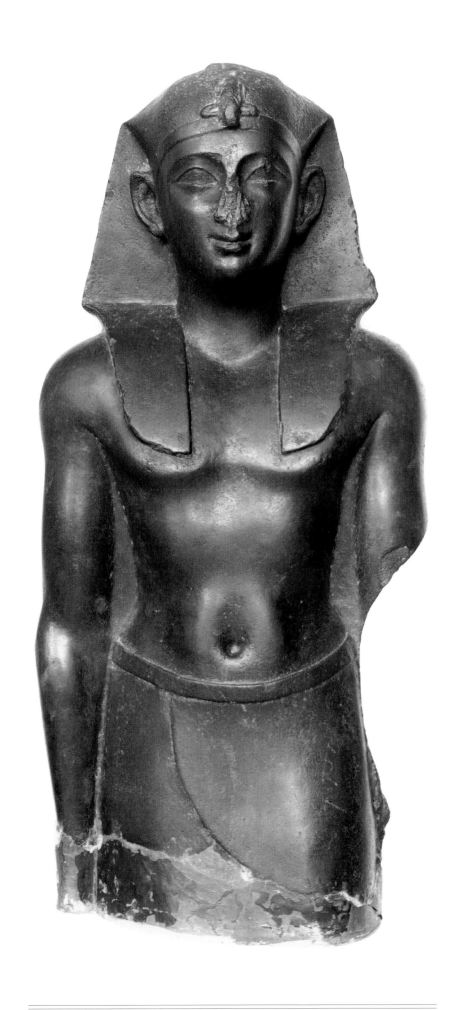

Limestone; h. 52.4 cm (20½ in.), w. 28 cm (11 in.), d. 4 cm (1½ in.)

Greco-Roman Period, Ptolemaic Dynasty, reign of Cleopatra VII Philopator, dated 2 July 51 BC

E 27113

Strange as it may seem, this stele does indeed honor and represent the legendary Cleopatra, identified by the Greek text as "Queen Cleopatra, the father-loving goddess" (_thea philopator_). We know the face of Cleopatra VII, daughter of Ptolemy XV Auletes, from her effigies on coins and a few rare Greek portraits that have nothing to do with the seductive image that nineteenth-century painting and the cinema have imprinted on us. This conventional scene sheds no further light on the features of this celebrated ruler.

Moreover, aside from its historical interest, this document underlines the gulf separating our conception of images and that of the Egyptians. The stele is composed according to the usual rules [compare 24]: winged disk at the top; ritual scene of the personage facing a divinity, the two separated by a table of offerings; dedicatory inscription at the bottom. The queen is represented as a male pharaoh wearing the Double Crown and the triangular kilt, according to tradition. She offers two vases to the goddess Isis, who nurses her baby Horus. The Egyptians were blissfully ignorant of the real traits of their Greek rulers and, caring only to respect tradition, continued endlessly reproducing the old pharaonic models. Even though the iconographic themes are purely Egyptian, the text is written in Greek, the language of the conquerors.

The careful observer will note that this stele has been recarved. The fine straight lines drawn on the borders to align the signs correctly do not coincide with those that appear in the recessed zone in which the inscription is actually carved. In addition, incompletely effaced characters are still discernible on the right margin.

Now, or so we think, all becomes clear. The stele dates to the beginning of the reign of Cleopatra, year one, the first day of the month of Epiphi, which the Hellenists translate as 2 July 51 BC. One of the best-dated monuments in the Egyptian department of the Louvre, it was first made to honor a Ptolemy, doubtless Cleopatra's father, and reworked at the change of reign. The Louvre's stele of Ptolemy XII Auletes is of similar inspiration. This sequence explains why the image of the ruler, which was preserved, is that of a man. In fact, the scene revives an old tradition, for earlier, in Dynasty 18, the Egyptians had represented Queen Hatshepsut as a male pharaoh.

The stele was commissioned in honor of the queen by a temple society under the patronage of Isis Sononais, a local form of the great goddess, who was probably worshiped in the Faiyum oasis. The president of this society and administrator of the temple was named Onnophris. BL

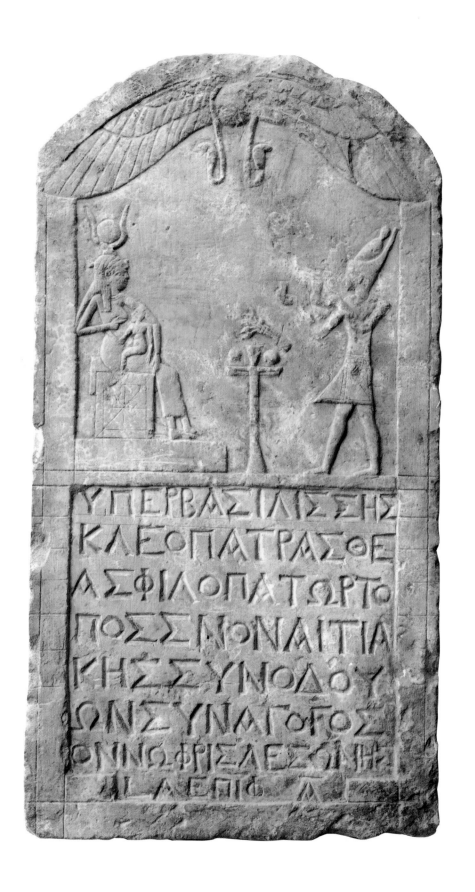

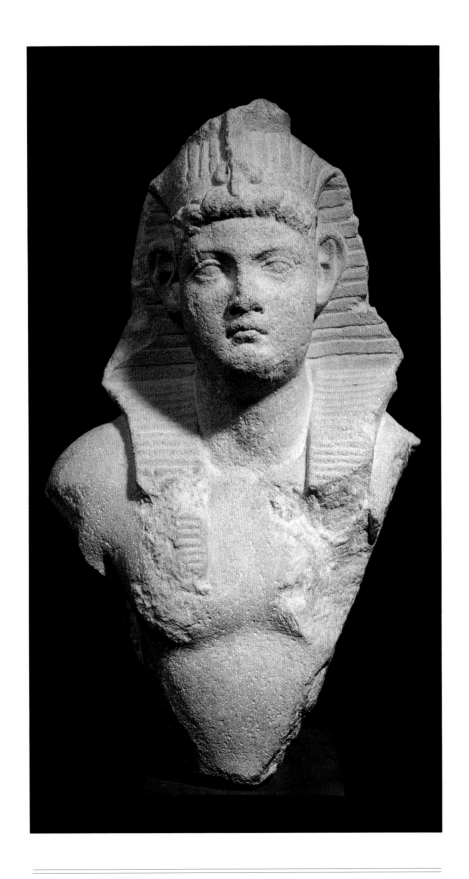

Marble; h. 28 (11 in.), w. 16.5 cm (6½ in.), d. 11.3 cm (4½ in.)

Greco-Roman Period, Roman Empire, reign of Nero, AD 54–68
E 27418

For the Romans, Egypt was a strategic area and a granary that had to be kept under the empire's control. Unlike their Greek predecessors, however, they did not settle in Egypt, sending only garrisons. Thus the Romans typically perceived Egyptian culture as exotic. Hadrian, in the second century, was one of the few emperors to demonstrate an intellectual and sentimental interest in the country. The language of culture remained Greek and documents drawn up in Latin are not numerous. The priests maintained the traditions, and only the cartouches of the kings, which transcribed in an approximate way the names of the emperors, tell us that the "pharaoh" officiating in the scenes on temple walls is, in fact, Tiberius, Nero, or Trajan. The Roman period still produced some beautiful works, such as the painted portraits known as "Faiyum portraits," but these were of Hellenic inspiration. Conversely, popular art degenerated, producing bastardized and careless works that repeated iconographic themes and hieroglyphic signs without an understanding of them.

This statuette reveals the final phase of ancient Egyptian civilization, and the treatment of the forms and the iconographic themes herald the works of Egyptomania. The stone itself is not one that was used in the pharaonic period. The ruler lacks any particularly Egyptian traits. The stocky, flaccid figure has a weak face with thick cheeks, heavy chin, and a small, fleshy mouth that droops at the corners. The eyelids are rendered by a border around the eyes.

The accessories, however, conform to pharaonic tradition. The statue has a back pillar, which is broken, and the figure wears the nemes-headdress with uraeus. This head cloth was probably surmounted by a crown, of which only the base survives. It is placed high on the head, allowing curls of hair to pass through. This detail gives the work a foreign aspect, which appears somewhat incongruous.

The statuette represents a Roman emperor whose features are similar to those of a statue in Mantua, Italy, that has been identified as Nero. Showing no more than a superficial interest in Egypt, Nero doubtless never stepped foot there. BL

Documentation

1. *Bull Palette*

PROVENANCE
Gift of Tigrane Pasha, 1886

EXHIBITED
Paris, Galeries nationales du Grand Palais, 29 May–3 September 1973: *L'Egypte avant les pyramides*, no. 18, p. 24; Paris, Galeries nationales du Grand Palais, 7 May–9 August 1982: *Naissance de l'écriture: Cunéiformes et hiéroglyphes*, no. 18 (entry by Jean-Louis de Cenival)

PUBLISHED
PM 1937, p. 105; Smith 1946/78, p. 112 (8), pl. 30, a; Heinrich Schäfer, *Principles of Egyptian Art*, ed. Emma Brunner-Traut, trans. and ed. John Baines (Oxford: Oxford University Press, 1974), pl. 2 (detail); Lurker 1980, p. 35; Smith 1981, p. 32, fig. 11; Janine Monnet Saleh, "Interprétation globale des documents concernant l'unification de l'Egypte," *BIFAO* 86 (1986): 232–33, pl. XXIX; Ziegler 1990, p. 17; Whitney Davis, *Masking the Blow: The Scene of Representation in Late Prehistoric Egyptian Art* (Berkeley: University of California Press, 1992), p. 144, fig. 37; Laclotte 1994, p. 37; Michalowski 1994, figs. 17–18

2. *Stele of Qahedjet*

PROVENANCE
Acquired 1967

PUBLISHED
Christiane Ziegler, *Catalogue des stèles, peintures et reliefs égyptiens de l'ancien empire* (Paris: Réunion des musées nationaux, 1990), no. 4; Ziegler 1990, p. 23; Michalowski 1994, fig. 28; Clayton 1994, p. 25

NOTES
For Djoser's reliefs from Saqqara and Heliopolis, see Smith 1946/78, pp. 132–39, figs. 48–53 and pl. 31a; Smith 1981, pp. 54, 61–62, 64, figs. 31, 51; Anna Maria Donadoni Roveri, ed., *Egyptian Civilization: Monumental Art*, Egyptian Museum of Turin (Milan: Electa, 1989), p. 200, figs. 301, 302. The identification of Qahedjet with Huni was suggested by Jacques Vandier, "Une stèle égyptienne portant un nouveau nom royal de la troisième dynastie," *Comptes rendus de l'Academie des inscriptions et belles-lettres* (January–March 1968): 16–22, and is followed in the chronology used in this catalogue.

3. *Head of Djedefra, from a Sphinx*

PROVENANCE
Abu Rawash, pyramid complex of Djedefra, excavations of Chassinat, 1900–01. Division of finds, 1907

EXHIBITED
Paris 1981, no. 53

PUBLISHED
E. Chassinat, "A propos d'une tête en grès rouge du roi Didoufrî (IVe dynastie) conservée au Musée du Louvre," *MonPiot* 25 (1921–22): 53–75, pls. VIII–X; Smith 1946/78, pp. 32–33, pl. 11, a–b; Patrik Reuterswärd, *Studien zur Polychromie der Plastik*, vol. 1, *Ägypten*, Acta Universitatis Stockholmiensis, Stockholm Studies in History of Art III:I (Stockholm: Almqvist and Wiksell, 1958), pp. 12, 14, pl. III. Vandier 1958, p. 16, pl. I, fig. 2; PM 1974, p. 2; John Baines and Jaromír Málek, *Atlas of Ancient Egypt* (New York: Facts on File, 1980), p. 165; Smith 1981, p. 116, fig. 112; Sally B. Johnson, *The Cobra Goddess of Ancient Egypt: Predynastic, Early Dynastic, and Old Kingdom Periods* (London and New York: Kegan Paul International, 1990), 30, pp. 83–84, figs. 137–39, cf. p. 27, fig. 38, pp. 193, 201; Ziegler 1990, p. 23; De Putter and Karlshausen 1992, p. 97, pl. 30; Clayton 1994; Laclotte 1994, p. 38; Michalowski 1994, fig. 249

NOTES
The most complete description of Djedefra's funerary monument is V. Maragioglio and C. Rinaldi, *L'architettura delle piramidi menfiti*, part 5, *Le piramidi di Zedefrâ e di Chefren*, Eng. trans. A. E. Howell (Rapallo, Italy: Officine Grafiche Canessa, 1986), pp. 6–41, pls. 2–4. For the Cairo heads of Djedefra (JE 35139 and 35138), see Smith 1946/78, pl. 11, c–d; Vandier 1958, pl. I, figs. 1, 3. For Djedefra's use of the title "son of Ra," see Vasil Dobrev, "Considérations sur les titulatures des rois de la IVe dynastie égyptienne," *BIFAO* 93 (1993): 191 n. 43, 196 n. 58, pl. X, fig. 29.

4. *Head of a King*

PROVENANCE
Acquired 1889, Cattaui collection

EXHIBITED
Marcq-en-Baroeul 1977–78, no. 2; Vienna 1992, no. 40

PUBLISHED
Vandier 1958, pp. 37, 172, pl. VIII, 6 (as Pepy II); Delange 1987, pp. 36–37

NOTES
For portraits of Mentuhotep III and Amenemhat I, see Dorothea Arnold, "Amenemhat I and the Early Twelfth Dynasty at Thebes," *Metropolitan Museum Journal* 26 (1991): 30–31, figs. 42, 44 (New York, Metropolitan Museum of Art, no. 66.99.3, and Cairo, Egyptian Museum, JE 60250, now in the Port Said National Museum); Vienna 1992, no. 39 (Mentuhotep III, Metropolitan Museum). For Sesostris I, see, for example, Luxor Museum of Ancient Egyptian Art, *Catalogue* (Cairo: American Research Center in Egypt, 1979), no. 25, pl. II.

5. *Seated Statue of Sesostris III*

PROVENANCE
Nag el-Madamud, excavations of Bisson de
la Roque, 1925. Division of finds, 1927

EXHIBITED
Paris 1981, no. 213; Tokyo 1991, no. 13 (en-
try by Elisabeth Delange)

PUBLISHED
F. Bisson de la Roque, *Rapport sur les fouilles
de Médamoud (1925)*, FIFAO 3 (Cairo:
Imprimerie de l'Institut français d'arché-
ologie orientale, 1926), 1:32, 33, pl. IV–B; PM
1937, p. 147; Vandier 1958, pl. LXII, 4;
Delange 1987, pp. 24–26; Ziegler 1990, p.
35, color; Clayton 1994, p. 83, top (errone-
ously as Sesostris II, Cairo Museum);
Laclotte 1994, p. 44

6. *Statuette of Amenemhat III*

PROVENANCE
Acquired 1926, Salt collection

EXHIBITED
Bologna 1990, no. 21 (entry by Gabriella
Porta); Vienna 1992, no. 48

PUBLISHED
Delange 1987, pp. 33–35; Biri Fay,
"Amenemhat V—Vienna/Assuan," *MDAIK*
44 (1988), pl. 27a; Hourig Sourouzian,
"Standing Royal Colossi of the Middle
Kingdom Reused by Ramesses II," *MDAIK*
44 (1988), pl. 73d; Guillemette Andreu,
*Images de la vie quotidienne en Egypte au
temps des pharaons* (Paris: Editions
Hachette, 1992), p. 120

NOTES
The quotation is from Herodotus, *The
Histories*, trans. Aubrey de Sélincourt, new
ed., rev. by A. R. Burn (Harmondsworth:
Penguin Books, 1954), p. 188. For the
Labyrinth and Byahmu, see Alan B. Lloyd,
Herodotus, Book II, vol. 3, *Commentary 99–
182*, Etudes préliminaires aux religions
orientales dans l'Empire romain 43
(Leiden: E. J. Brill, 1988), pp. 120–24, 126,
and the literature cited there; Claude
Obsomer, "Hérodote, Strabon et le
'mystère' du labyrinth d'Egypte," in
Claude Obsomer and Anne-Laure
Oosthoek, eds., *Amosiadès: Mélanges offerts
au Professeur Claude Vandersleyen par ses
anciens étudiants* (Louvain: n. p., 1992), pp.
221–324, pls. I–IX.

7. *Torso of Queen Sebekneferu*

PROVENANCE
Acquired 1973

EXHIBITED
Vienna 1994, no. 3 (entry by Elisabeth
Delange)

PUBLISHED
Delange 1987, pp. 30–31; Elisabeth
Staehelin, "Zum Ornat an Statuen
regierender Königinnen," *Bulletin Société
d'Egyptologie Genève* 13 (1989): 145–56, fig. 1;
Jean-Luc Chappaz, "Comment une femme
put devenir roi," *Les dossiers d'archéologie* 187
(November 1993), p. 9

8. *Seated Statue of Sebekhotep IV*

PROVENANCE
Probably el-Moalla. Acquired 1826, Salt
collection

EXHIBITED
Vienna 1994, no. 2 (entry by Elisabeth
Delange)

PUBLISHED
Vandier 1958, pl. LXXII, 5; Delange 1987,
pp. 20–21

NOTES
For a list of royal statues of Dynasty 13, see
Davies 1981, pp. 21–29, no. 22 for the Cairo
statue (JE 37486; Vandier 1958, pl. LXXII, 6).

9. *Relief of Tuthmosis III*

PROVENANCE
Elephantine Island, temple of Satis, excava-
tions of Clermont-Ganneau, 1906

EXHIBITED
Paris 1981, no. 259 (entry by Elisabeth
Delange)

PUBLISHED
Myśliwiec 1976, pl. XXXVI, fig. 84 (detail)

NOTES
For the temple of Hatshepsut and
Tuthmosis III on Elephantine Island and its
reconstruction, see Werner Kaiser et al.,
"Stadt und Tempel von Elephantine:
Achter Grabungsbericht," *MDAIK* 36 (1980):
250–64, pls. 57–59; Werner Kaiser,
"Hatchepsout à Eléphantine," *Les dossiers
d'archéologie* 187 (November 1993): 102–9.
For the falcon, see Myśliwiec 1985, pp. 156–
60, pls. V–VI (p. 157 n. 24 for this relief).

10. *King As Falcon*

PROVENANCE
Acquired 1868, Rousset-Bey collection

EXHIBITED
Hildesheim, Roemer- und Pelizaeus Mu-
seum, 3 August–29 November 1987:
Ägyptens Aufstieg zur Weltmacht, no. 104
(entry by Christophe Barbotin); Bologna
1990, no. 37 (entry by Gabriella Porta);
Vienna 1992, no. 87

PUBLISHED
Paule Kriéger, "Une statuette de roi-
faucon au Musée du Louvre," *RdE* 12
(1960): 37–58, pls. 3–4; Ziegler 1990, p. 46

NOTES
For a list of small-scale royal statuary of
Tuthmosis III, see Bryan, in Cleveland/
Fort Worth/Paris 1992–93, p. 197 n. 5. A
statue in Cairo even shows him in the
Chephren pose, with the falcon in back of
his crown; Ludwig Borchardt, *Statuen und
Statuetten von Königen und Privatleuten im
Museum von Kairo* (Berlin: Reichsdruckerei,
1930), no. CG 743, pl. 137; Myśliwiec 1985,
p. 148 n. 26 (for the identification as
Tuthmosis III).

11. *Bust of Tuthmosis IV*

PROVENANCE
Nag el-Madamud, excavations of Bisson de la Roque, 1929, inv. 4467. Division of finds

EXHIBITED
Paris 1981, no. 253 (entry by Monique Nelson)

PUBLISHED
F. Bisson de la Roque, *Rapport sur les fouilles de Médamoud (1929)*, FIFAO 7 (Cairo: Imprimerie de l'Institut français d'archéologie orientale, 1930), 1:29, fig. 24; PM 1937, p. 149 (as "red granite bust of unidentified king"); Betsy M. Bryan, "Portrait Sculpture of Thutmose IV," *Journal of the American Research Center in Egypt* 24 (1987): 12–14, figs. 16–17, 19 (for the first time identifying the portrait as Tuthmosis IV); De Putter and Karlshausen 1992, p. 84, pl. 24

NOTES
The quotation from the Sphinx Stele is from Betsy M. Bryan, *The Reign of Thutmose IV* (Baltimore and London: Johns Hopkins University Press, 1991), p. 146.

12. *Head of Amenhotep III*

PROVENANCE
Acquired 1827, Drovetti collection

EXHIBITED
Strasbourg/Paris/Berlin 1990–91, no. H12; Tokyo 1991, no. 17 (entry by Elisabeth Delange); Cleveland/Fort Worth/Paris 1992–93, no. 10 (entry by Betsy M. Bryan)

PUBLISHED
Vandier 1958, pl. CV, 3; Müller 1988, pp. IV–46, 47; Ziegler 1990, p. 46; Robert Steven Bianchi, "Aménophis III: Le pharaon-soleil," *Archéologia* 288 (March 1993): 21; Elisabeth Delange, "Aménophis III: Le pharaon-soleil," *Les dossiers d'archéologie* 180 (March 1993); Jean Yoyotte, "Aménophis III: Soleil des souverains," *Beaux Arts*, hors série (1993), p. 16

13. *Seated Statue of Amenhotep IV (Akhenaten)*

PROVENANCE
Acquired 1826, Salt collection

EXHIBITED
Tokyo 1991, no. 19 (entry by Elisabeth Delange); Paris/Ottawa/Vienna 1994–95, no. 234 (entry by Christiane Ziegler)

PUBLISHED
Champollion le Jeune, *Notice descriptive des monuments égyptiens du Musée Charles X* (Paris: De l'Imprimerie de Crapelet, 1827), p. 55, no. 11; Vandier 1958, pl. CX, 2; Aldred 1973, p. 48, fig. 29; Kanawaty 1985, p. 38, pl. IVa; Müller 1988, pp. IV–143, 144; Clayton 1994 (detail)

14. *Pair Statuette of Amenhotep IV (Akhenaten) and Nefertiti*

PROVENANCE
Bequest of Atherton, Louise, and Ingeborg Curtis, 1938

PUBLISHED
PM 1934, p. 235 (as "at a dealer's in Cairo"); Charles Boreux, "Trois oeuvres égyptiennes de la donation Atherton Curtis (Musée du Louvre)," *MonPiot* 37 (1940): 25–36, pl. III; Vandier 1958, pl. CXI, 1; Aldred 1973, p. 63, figs. 39–40; Cyril Aldred, *Akhenaten, King of Egypt* (London: Thames and Hudson, 1988), pls. 20–21; Müller 1988, p. IV–142; Ziegler 1990, p. 47; Jaromír Málek, ed., *Egypt—Ancient Culture, Modern Land*, Cradles of Civilization (North Sydney: Weldon Russell, 1993), p. 74; Clayton 1994 (detail); Laclotte 1994, p. 49; Michalowski 1994, fig. 506

15. *Talatat: Amenhotep IV (Akhenaten) in Sed-Festival Costume*

PROVENANCE
Probably Karnak. Acquired 1968

PUBLISHED
J. J. Clère, "Nouveaux fragments de scènes du jubilé d'Aménophis IV," *RdE* 20 (1968): 51–54, pl. 3; Jacques Vandier, "Chronique des musées—Nouvelles acquisitions: Musée du Louvre, Département des antiquités égyptiennes," *La revue du Louvre* 19, no. 1 (1969): 45, 47, fig. 6

NOTES
For the Gempaaten, see Donald B. Redford, *Akhenaten, The Heretic King* (Princeton: Princeton University Press, 1984), pp. 102–36. For the sed-festival blocks in particular, see Jocelyn Gohary, *Akhenaten's Sed-Festival at Karnak*, Studies in Egyptology (London and New York: Kegan Paul International, 1992)

16. *Statue of the God Amen Protecting Tutankhamen*

PROVENANCE
Gift of Delort de Gléon, 1903

EXHIBITED
Marcq-en-Baroeul 1977–78, no. 6 (no illus.); Paris/Ottawa/Vienna 1994–95, no. 345 (Ottawa and Vienna only; entry by Christiane Ziegler)

PUBLISHED
Vandier 1958, pp. 366–67, pl. CXVIII, 3

17. *Relief of Tjutju Adoring King Menkauhor and Divinities*

PROVENANCE
Found by Mariette in the constructions of the Serapeum (chamber of Ramesses IV), but probably from a Saqqara tomb chapel. Sent 1854

PUBLISHED
Jocelyne Berlandini, "Varia Memphitica I (I)," *BIFAO* 76 (1976): 315; Berlandini, "La pyramide 'ruinée' de Sakkara-Nord et Menkauohor," *BSFE* 83 (October 1978): 25, 27, fig. 2; Berlandini, "La pyramide 'ruinée' de Sakkara-Nord et le roi Ikaouhor-Menkaouhor," *RdE* 31 (1979): 19, 17, pl. 2B; PM 1981, p. 820

18. *Relief of a King, Probably Ramesses II*

PROVENANCE
Bequest of Atherton, Louise, and Ingeborg Curtis, 1938

EXHIBITED
Marcq-en-Baroeul 1977–78, no. 7; Rome, Palazzo Ruspoli, 6 October 1994–19 February 1995: *Nefertari, Luce D'Egitto*, no. 16 (entry by Elisabeth Delange)

19. *Head and Torso of King Merenptah As a Standard-Bearer*

PROVENANCE
Acquired 1961

PUBLISHED
Jacques Vandier, "Un buste de Mineptah," *La revue du Louvre* 13, no. 4–5 (1963): 153–58, figs. 1–3; Catherine Chadefaud, *Les statues porte-enseignes de l'Egypte ancienne (1580–1085 av. J.C.)* (Paris, 1982), p. 54; Hourig Sourouzian, *Les monuments du roi Merenptah*, Deutsches Archäologisches Institut, Abteilung Kairo, Sonderschrift 22 (Mainz: Philipp von Zabern, 1989), p. 205, doc. 127, pl. 38, a; Ch. Barbotin, "Les Ramessides," *Le Monde de la Bible* 78 (September–October 1992): 20, fig. 20; De Putter and Karlshausen 1992, p. 46, pl. 2 (photo reversed)

20. *Funerary Figurine of Ramesses IV*

PROVENANCE
Acquired before 1850

PUBLISHED
Jean Yoyotte, in *Dictionnaire de la civilisation égyptienne* (Paris: Fernand Hazan, 1959, 1970), p. 267; Jacques-F. Aubert and Liliane Aubert, *Statuettes égyptiennes: chaouabtis, ouchebtis* (Paris: Librairie d'Amèrique et d'Orient Adrien Maisonneuve, 1974), p. 118; Lurker 1980, p. 126; Ziegler 1990, p. 53

NOTES
For the scenes from the tomb of Ramesses IV, see Hans D. Schneider, *Shabtis: An Introduction to the History of Ancient Egyptian Funerary Statuettes with a Catalogue of the Collection of Shabtis in the National Museum of Antiquities at Leiden* (Leiden: Rijksmuseum van Oudheden, 1977), pp. 265–66 and fig. 38.

21. *Ostracon with Portrait of Ramesses VI*

PROVENANCE
Thebes, Valley of the Kings (?). Acquired 1827, Drovetti collection

EXHIBITED
Strasbourg/Paris/Berlin 1990–91, no. H9

PUBLISHED
J. Vandier d'Abbadie, *Catalogue des ostraca figurés de Deir el Médineh* (1936–37), vol. 2, no. 2570 and pl. LXXIV; Myśliwiec 1976, p. 133, fig. 302; William H. Peck, *Drawings from Ancient Egypt* (London: Thames and Hudson, 1978), p. 54, pl. II, detail; Kanawaty 1985, pp. 41, 44 (illus.); Ziegler 1990, p. 52; Michalowski 1994, fig. 156

22. *Block of Osorkon I Offering*

PROVENANCE
Bubastis, excavations of Naville. Gift of the Egypt Exploration Fund, 1889

EXHIBITED
Paris, Galeries nationales du Grand Palais, 26 March–20 July 1987; and Marseille, Centre de la Vielle Charité, 19 September–30 November 1987: *Tanis: L'or des pharaons*, no. 44 (entry by Geneviève Pierrat)

PUBLISHED
Ziegler 1990, p. 71

23. *Head of a Saite Ruler, Probably Apries*

PROVENANCE
Acquired 1859, Palin collection

EXHIBITED
Aix-en-Provence 1995; Barbotin 1995, p. 20

PUBLISHED
P. Pierret, *Catalogue de la Salle Historique de la Galerie égyptienne* (1889), p. 53, no. 247; Bothmer 1950, p. 59 (cited); Jacques Vandier, "Une tête royale de l'époque saîte," *Zeitschrift für Ägyptische Sprache und Altertumskunde* 90 (1963): 117, pl. XIII, 1–2; Jean Leclant, ed., *L'Egypte du crépuscule*, L'univers des formes (Paris: Gallimard, 1980), p. 144, fig. 126; Jack A. Josephson, "Royal Sculpture of the Later XXVIth Dynasty," *MDAIK* 48 (1992): 94, pl. 16, c; Clayton 1994, p. 196 bottom

24. *Epitaph for an Apis Bull*

PROVENANCE
Saqqara, Serapeum, tomb of Apis XLI, excavations of Mariette

PUBLISHED
PM 1974, p. 797; Emile Chassinat, "Textes provenant du Sérapéum de Memphis," *Recueil de travaux* 22 (1900): 20; James Henry Breasted, *Ancient Records of Egypt* (1906; reprint London: Histories and Mysteries of Man, 1988), 4:513–14; Jean Vercoutter, "Une épitaphe royale inédite du Sérapéum," *MDAIK* 16 (1960): 335, pl. XXXII

25. *Head of an Achaemenian Ruler*

PROVENANCE
Acquired 1936

EXHIBITED
Aix-en-Provence 1995

PUBLISHED
Robert Lunsingh Scheurleer, "Quelques terres cuites memphites," *RdE* 26 (1974): 90–91

NOTES
For the limestone head, see Georges Michaélidis, "Quelques objets inédits d'époque perse," *Annales du Service des Antiquités de l'Egypte* 43 (1943): 102, fig. 36. For the terracotta head from Memphis, see W. M. Flinders Petrie, *Memphis I*, Egyptian Research Account 15 (London: School of Archaeology in Egypt, 1909), pl. XXXVI, 16.

26. *Head of Nectanebo I (Nakhtnebef)*

PROVENANCE
Acquired 1972. Formerly in the Flameng and Allez collections

EXHIBITED
Aix-en-Provence 1995

PUBLISHED
Vandier 1973, pp. 112–13 (4), figs. 14, a–c, Barbotin 1995, p. 21

27. *Relief of Nectanebo II (Nakhthorheb) Adoring Apis*

PROVENANCE
Saqqara, Serapeum, excavations of Mariette, East Temple

EXHIBITED
Marcq-en-Baroeul, no. 9 (no illus.); Brooklyn/Detroit/Munich 1988–99, no. 10

PUBLISHED
PM 1981, p. 779

28. *Head and Torso of a Ptolemy*

EXHIBITED
Brooklyn/Detroit/Munich 1988–99, no. 59

PUBLISHED
Bothmer 1960, p. 162 (cited)

29. *Stele Dedicated to Queen Cleopatra VII Philopator*

PROVENANCE
Probably the Faiyum region. Acquired 1972

EXHIBITED
Brooklyn/Detroit/Munich 1988–99, no. 78

PUBLISHED
Vandier 1973, pp. 113–14 (5), fig. 16; Guy Wagner, "Une dédicace à la grande Cléopâtra de la part du synode snonaïtique, 2 juillet 51 av. J.-C.," *BIFAO* 73 (1973): 103–8; E. Bernand, *Inscriptions grecques d'Egypte et de Nubie au Musée du Louvre* (Paris: Editions du CNRS, 1992), p. 62, no. 21, pl. 17

30. *Head and Torso of a Roman Emperor, Probably Nero*

PROVENANCE
Acquired 1986

PUBLISHED
J. L. de Cénival, "Récente acquisitions des musées nationaux—Musée du Louvre," *La revue du Louvre* 36, no. 6 (1986): 432, fig. 2; Ziegler 1990, p. 84; Michalowski 1994, fig. 182

NOTES
Zsolt Kiss, "Notes sur le portrait impérial romain en Egypte," *MDAIK* 31 (1975): 293–302; Kiss, *Etudes sur le portrait impérial romain en Egypte*, Travaux du Centre d'archéologie méditerranéenne de l'Académie polonaise des sciences 23 (Warsaw: Editions scientifiques de Pologne, 1984); the statue in Mantua (Museo del Palazzo Ducale 98) is illustrated in Kiss, *Etudes sur le portrait impérial romain en Egypte*, p. 142, fig. 80.

Exhibitions

Aix-en-Provence 1995
Aix-en-Provence, Musée Granet, 24 May–
6 November 1995: *Les derniers Pharaons:
L'art en Egypte du VII^e au I^e siècle av. J.C.*

Bologna 1990
Bologna, Museo Civico Archeologico,
25 March–15 July 1990: *Il senso dell'arte
nell'Antico Egitto.* Catalogue by various
authors

Brooklyn/Detroit/Munich 1988–89
The Brooklyn Museum, 7 October 1988–
2 January 1989; The Detroit Institute of
Arts, 14 February–30 April 1989; Munich,
Kunsthalle der Hypo-Kulturstiftung, 8
June–10 September 1989: *Cleopatra's Egypt:
Age of the Ptolemies.* Catalogue

Cleveland/Fort Worth/Paris 1992–93
The Cleveland Museum of Art, 1 July–
27 September 1992; Fort Worth, Kimbell
Art Museum, 24 October 1992–31 January
1993; Paris, Galeries Nationales du Grand
Palais, 2 March–31 May 1993: *Egypt's Daz-
zling Sun: Amenhotep III and His World.*
Catalogue by Arielle P. Kozloff and Betsy
M. Bryan with Lawrence M. Berman

Marcq-en-Baroeul 1977–78
Marcq-en-Baroeul, Fondation Anne et
Albert Prouvost Septentrion, October
1977–January 1978: *L'Egypte des Pharaons.*
Catalogue

Paris 1981
Paris, Musée d'Art et d'Essai-Palais de
Tokyo, 21 May–15 October 1981: *Un siècle
de fouilles françaises en Egypte 1880–1980.*
Catalogue edited by Ch. Desroches
Noblecourt and Jean Vercoutter

Paris/Ottawa/Vienna 1994–95
Paris, Musée du Louvre, 20 January–
18 April 1994; Ottawa, Musée des beaux-
arts du Canada, 17 June–18 September
1994; Vienna, Kunsthistorisches Museum,
15 October 1994–15 January 1995: *Egypto-
mania: L'Egypte dans l'art occidentale 1730–
1930.* Catalogue by Jean-Marcel Humbert,
Michael Pantazzi, and Christiane Ziegler

Strasbourg/Paris/Berlin 1990–91
Strasbourg, L'Eglise Saint-Paul, 1 June–
7 October 1990; Paris, Bibliothèque
Nationale, 16 November 1990–17 March
1991; and Berlin, Egyptian Museum, 11
May–15 August 1991: *Memoires d'Egypte:
Hommage de l'Europe à Champollion.* Notices
descriptives des objets présentés

Tokyo 1991
Tokyo, National Museum of Western Art,
18 September–1 December 1991: *Portraits
du Louvre: Choix d'oeuvres dans les collections
du Louvre.* Catalogue by various authors

Vienna 1992
Vienna, Künstlerhaus, 25 May–4 October
1992: *Gott, Mensch, Pharao: Viertausend
Jahre Menschenbild in der Skulptur des Alten
Ägypten.* Catalogue by Wilfried Seipel

Vienna 1994
Vienna, Rathaus Wien, Volkshalle, 8 Sep-
tember–23 October 1994: *Pharaonen und
Fremde: Dynastien im Dunkel.* Catalogue

Publications

Aldred 1973
Cyril Aldred. *Akhenaten and Nefertiti.* Exh.
cat. New York: Brooklyn Museum in asso-
ciation with Viking Press, 1973

Barbotin 1995
Christophe Barbotin and Olivier Perdu,
"Les dernier pharaons," *Archéologia* 313
(June 1995): 18–33

BIFAO
*Bulletin de l'Institut français d'archéologie
orientale*

Bothmer 1960
Bernard V. Bothmer. *Egyptian Sculpture of
the Late Period, 700 B.C. to A.D. 100.* Exh. cat.
New York: Brooklyn Museum, 1960

BSFE
Bulletin de la Société française d'égyptologie

CG
*Catalogue général des antiquités
égyptiennes du Musée du Caire*

Clayton 1994
Peter A. Clayton. *Chronicle of the Pharaohs:
The Reign-by-Reign Record of the Rulers and
Dynasties of Ancient Egypt.* London: Thames
and Hudson, 1994

Davies 1981
W. V. Davies. *A Royal Statue Reattributed.*
British Museum Occasional Paper 28.
London: British Museum, 1981

Delange 1987
Elisabeth Delange. *Catalogue des statues
égyptiennes du Moyen Empire.* Paris:
Réunion des musées nationaux, 1987

De Putter and Karlshausen 1992
Thierry de Putter and Christina
Karlshausen. *Les pierres utilisées dans la
sculpture et l'architecture de l'Egypte
pharaonique: Guide pratique illustré.*
Brussels: Connaissance de l'Egypte
ancienne, 1992

FIFAO
*Fouilles de l'Institut français d'archéologie
orientale*

Kanawaty 1985
Monique Kanawaty. "Les acquisitions du
Musée Charles X," *BSFE* 104 (October
1985): 31–54

Laclotte 1994
Michel Laclotte. *Treasures of the Louvre.*
New York: Abbeville Press, 1994

Lurker 1980
Manfred Lurker. *An Illustrated Dictionary
of the Gods and Symbols of Ancient Egypt.*
English edition, revised and picture-edited
by Peter Clayton. London: Thames and
Hudson, 1980

MDAIK
*Mitteilungen des Deutschen Archäologischen
Instituts, Abteilung Kairo*

Michalowski 1994
Kazimierz Michalowski. *L'Art de l'Egypte*.
New edition, revised and augmented by
Jean-Pierre Corteggiani and Alessandro
Roccatti. Paris: Citadelles et Mazenod,
1994

MonPiot
Fondation Eugène Piot, Monuments et
Mémoires

Müller 1988
Maya Müller. *Die Kunst Amenophis' III. und
Echnatons*. Basel: Verlag für Ägyptologie,
1988

Myśliwiec 1976
Karol Myśliwiec. *Le portrait royal dans le
bas-relief du Nouvel Empire*. Travaux du
Centre d'archéologie méditerranéenne de
l'Académie polonaise des sciences, no. 18.
Warsaw: Editions scientifiques de Pologne,
1976

Myśliwiec 1985
Karol Myśliwiec. "Quelques remarques sur
les couronnes à plumes de Thoutmosis III."
In *Mélanges Gamal eddin Mokhtar*. Vol. 2,
pp. 149–60, pls. I–VI. Bibliothèque d'étude,
no. 97/2. Cairo: Institut français d'arché-
ologie orientale, 1985

PM 1934
Bertha Porter and Rosalind L. B. Moss.
*Topographical Bibliography of Ancient Egyptian
Hieroglyphic Texts, Reliefs, and Paintings*.
Vol. 4, *Lower and Middle Egypt*. Oxford:
Clarendon Press, 1934

PM 1937
Bertha Porter and Rosalind L. B. Moss.
*Topographical Bibliography of Ancient Egyptian
Hieroglyphic Texts, Reliefs, and Paintings*.
Vol. 5, *Upper Egypt: Sites*. Oxford: Clarendon
Press, 1937

PM 1974
Bertha Porter and Rosalind L. B. Moss.
*Topographical Bibliography of Ancient Egyptian
Hieroglyphic Texts, Reliefs, and Paintings*.
Vol. 3, *Memphis*. Part 1, *Abû Rawâsh to Abûsîr*.
Oxford: Clarendon Press, 1974

PM 1981
Bertha Porter and Rosalind L. B. Moss.
*Topographical Bibliography of Ancient Egyptian
Hieroglyphic Texts, Reliefs, and Paintings*.
Vol. 3, *Memphis*. Part 2, *Saqqâra to Dahshûr*.
Second edition, revised and augmented by
Jaromír Málek. Oxford: Griffith Institute,
Ashmolean Museum, 1981

RdE
Revue d'égyptologie

Smith 1946/78
William Stevenson Smith. *A History of
Egyptian Sculpture and Painting in the Old
Kingdom*. 1946; reprint New York: Hacker
Art Books, 1978

Smith 1981
William Stevenson Smith. *The Art and Ar-
chitecture of Ancient Egypt*. Second edition,
revised by William Kelly Simpson. Pelican
History of Art. New Haven and London:
Yale University Press, 1981

Vandier 1958
J. Vandier. *Manuel d'archéologie égyptienne*.
Vol. 3, *La statuaire*. Paris: Editions A. et
J. Picard et Cie, 1958

Vandier 1973
Jacques Vandier, "Département des
antiquités égyptiennes: Acquisitions en
1973," *La revue du Louvre* 23, no. 2 (1973):
107–16

Ziegler 1990
Christiane Ziegler. *The Louvre. Egyptian
Antiquities*. Paris: Editions Scala, 1990